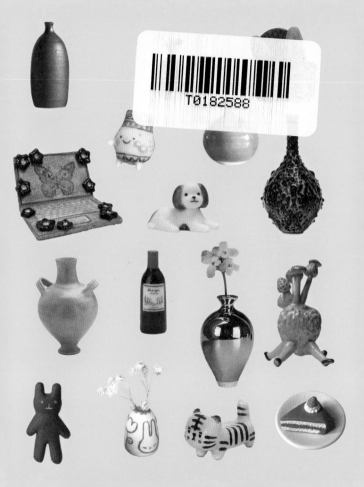

T0182588

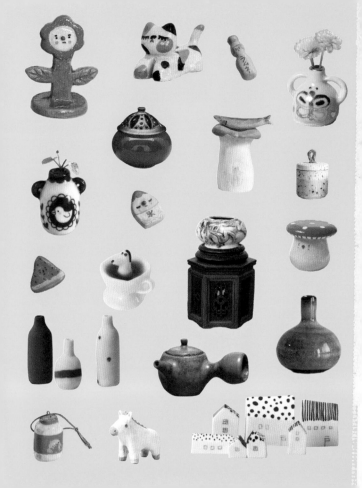

CLAY-FUL

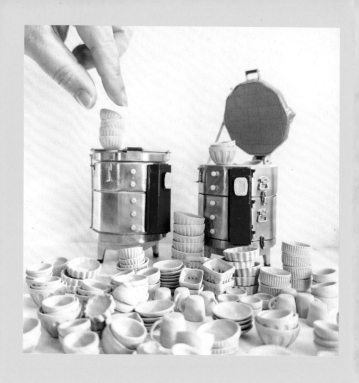

Cielo Vianzon, *Kiln Loading Day*, 2023, Earthenware and stoneware, Largest piece 1 cm x 2.5 cm (½ in x ⅞ in)

The big world of tiny ceramics

CLAY-FUL

Sophia Cai

Smith
Street
Books

CONTENTS

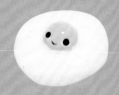

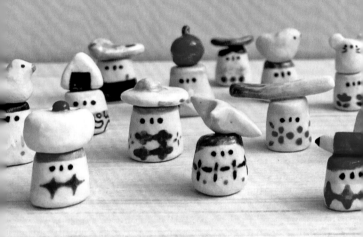

PREVIOUS PAGE
Ada Varaschini, *Egg*, 2022, Stoneware, 0.5 cm x 2 cm (¼ in x ¼ in)

THIS PAGE
Fung Wing Yan, *What's On Their Head*, 2022, Stoneware,
Largest piece 2 cm x 1.5 cm (¾ in x ½ in)

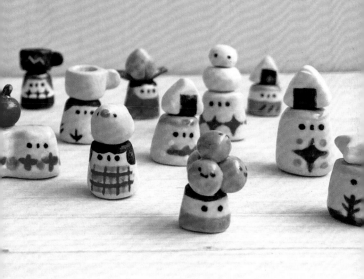

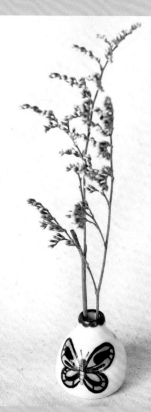

Annabel Le, *Birdwing Butterfly Vase*, 2023, Porcelain, 2.5 cm x 2 cm (1 in x ¾ in)

INTRODUCTION

Living in a small apartment with limited display space, my eyes and heart (and shelves) have long been captured by tiny art. My obsession with tiny ceramics in particular was fuelled by a trip to Seoul in 2019, where I discovered the variety of miniature porcelain pots on offer at museum gift shops. That year, everyone in my family received tiny ceramics as a Christmas present.

Working on *Clayful* has been an astute reminder of the creative possibilities granted from working with clay on a small scale, and why it remains such a compelling medium for so many. This book brings together a diverse group of 32 artists from all corners of the world who make small ceramics; the pieces featured measure up to 10 cm (4 in), with some larger works included that contain miniature parts. *Clayful* covers both functional works (mini pots and vases, lidded teapots, USB sticks) as well as sculptural and decorative pieces intended to simply make life more beautiful.

There are many reasons why the artists in *Clayful* choose to work at this scale: for some, it is a practical concern, motivated by space, cost or access needs, while for others miniatures provide fertile ground for experimentation and risk-taking, allowing them to push boundaries with greater freedom. Of course, there is also the inevitable 'cute aggression'. It comes with making art that can fit in the palm of your hand - like creating and playing with a miniature world.

The works shown here represent a full range of ceramic techniques and methods akin to their full-scale counterparts - from hand-building (including coiling, pinching and slab-building) to wheel-throwing, 3D printing and slip-casting. And this is all before the ceramics are even painted or glazed. In this way, the diversity of works and styles in *Clayful* offers a snapshot of contemporary ceramics practice and the multitude of imaginative ways that artists are using the medium today.

Aside from a common love for clay and miniatures, the artists in these pages also share thematic links and influences. In *Clayful*, you will find artists whose creations are a playful nod to childhood nostalgia, alongside others whose works tackle

themes of imagination and creative world-building. A number make work as an ongoing form of cultural connection and storytelling, translating historical ceramic traditions and visual narratives into the 21st century for new audiences.

What is clear from the artists in *Clayful* is that a small scale does not mean less effort or mastery. In fact, working on this scale requires creative problem-solving, such as crafting unique tools or building tiny pottery wheels from scratch. Miniatures present unforeseen challenges and can test artists' skills and adaptability.

This is one of the aspects I appreciate most about tiny art: the sense of wonder or delight we might feel at first glance is furthered by the realisation that there is more than meets the eye. Each object is a discovery, waiting to happen. And better yet, they can fit neatly on my apartment shelf.

SOPHIA CAI,
February 2024

Ada Varaschini

Describing her work as 'friend-shaped ceramics', Ada Varaschini, under the name Ada's Dolls, explores the fine line of 'the ugly-cute'.

This includes blobfish, round pigeons, and other creatures that are embellished with large eyes and butt cheeks or dimples. For Ada, this process is akin to adding googly eyes to common objects to change their meaning: 'If you put eyes on it, pretty much anything can become silly and cute.'

Ada first came to ceramics after hand-making dolls with upcycled fabrics, but it was COVID-19's lengthy lockdowns, and the lack of ready access to studio space, that spurred her miniature work: she could make small ceramics from home instead of a pottery studio.

BELOW
Pigeon, 2022, Stoneware,
4 cm x 4 cm (1½ in x 1½ in)

OPPOSITE
Swimming Pool, 2024, Stoneware,
3 cm x 7 cm (1¼ in x 2¾ in)

Ada enjoys working on a small scale and says the process is 'meditative and soothing'. Describing herself as someone who has difficulty focusing, she finds miniature work comforting and appreciates the creative problem-solving required.

 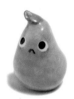

ABOVE
(L) *Orange*, 2022, Stoneware, 2 cm (¾ in)
(R) *Booty Pear*, 2022, Stoneware,
2 cm x 1 cm (¾ in x ½ in)

OPPOSITE
Seductive Blob, 2023, Stoneware,
5 cm x 5 cm (2 in x 2 in)

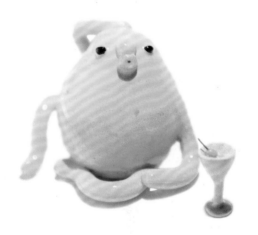

Andrea Fabrega

Andrea started selling her miniature ceramics in January 1992, earning her International Guild for Miniature Artisans Fellow status in 1994.

She describes herself as a 'collector and experimenter' at heart. Her pieces are inspired by her love for decorative arts and ceramics history, as well as her treasured childhood dollhouse. Today, Andrea makes 'what [she] would like to have', and her oeuvre spans tiny pots and items like miniature furniture, as well as full-sized pots and sculpture.

Andrea's works are typically made using porcelain, which she chooses for its smooth and translucent finish. Furthermore, porcelain has a shrinkage rate of almost 20 per cent – while most potters grudgingly accept shrinkage, Andrea loves it.

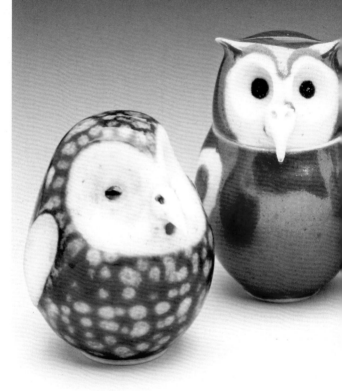

Four Lidded Containers in the Shape of Owls, 2005,
English porcelain, Largest piece 3.5 cm (1½ in) tall

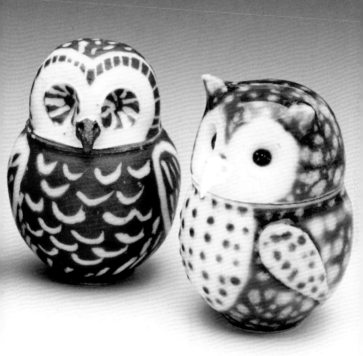

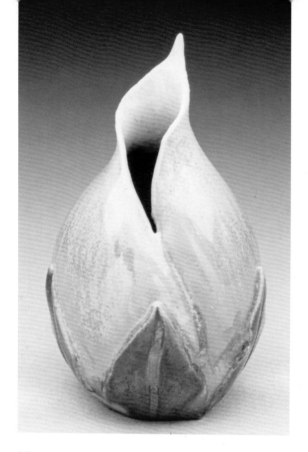

Working with miniature ceramics for a long time can take a physical toll on the body, as it requires focus and concentration. For Andrea, her routine includes regular breaks, as well as lots of cardio and yoga to maintain her physical fitness. It is this commitment, along with Andrea's international network of collectors and love of clay, that has inspired her to keep experimenting and testing out new ideas.

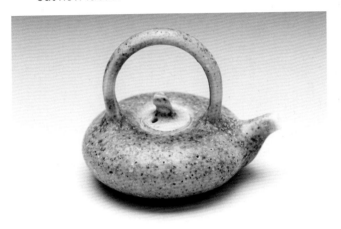

OPPOSITE
Crystalline Opening Bud, 2000, English porcelain, 3.5 cm (1½ in) tall

ABOVE
Flattened Teapot, 1999, English porcelain, 2.5 cm (1 in) tall

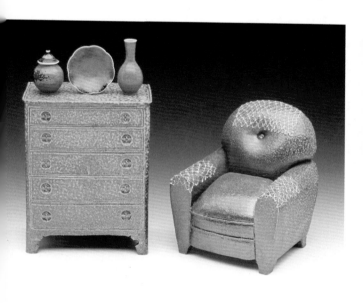

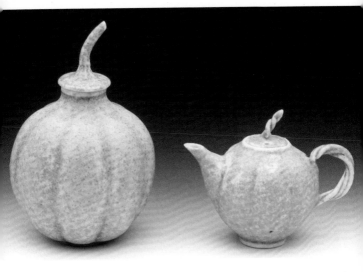

OPPOSITE
Tableau, 2004, Stoneware furniture and porcelain vessels,
Largest piece 9 cm (3½ in) tall

ABOVE
Gourd Vessels with Speckled Yellow Mat Glaze, 1997,
English porcelain, Largest piece 3 cm (1¼ in) tall

Annabel Le

Annabel Le started making miniature vases on a pottery wheel after experimenting with small, hand-built sculptures of food and animals. Her ceramics express a unique illustrative style across scales. On the miniature end of her work, she finds pieces become precious: 'instantly loveable by everyone who is so fascinated with small trinkets'.

Growing up as a half Viet-Chinese and Singaporean in Australia, Annabel's art is in part inspired by her culture and heritage. Many of her pieces draw on both traditional Chinese and Peranakan porcelain. Peranakan porcelain ('Peranakan' means 'person born here' in Malay), is also known as 'Straits Chinese porcelain' and arose as a unique cultural hybrid following the migration of Chinese merchants to maritime Southeast Asia, including Indonesia, Malaysia and Singapore.

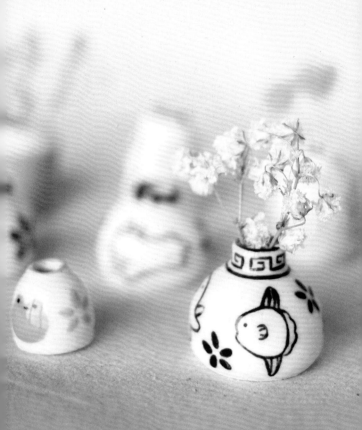

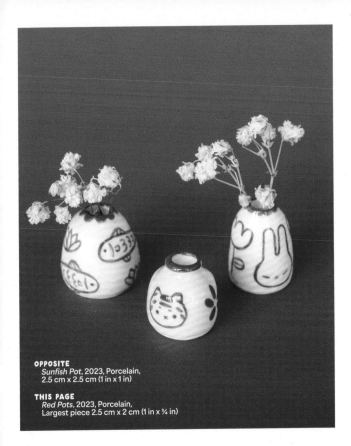

OPPOSITE
Sunfish Pot, 2023, Porcelain,
2.5 cm x 2.5 cm (1 in x 1 in)

THIS PAGE
Red Pots, 2023, Porcelain,
Largest piece 2.5 cm x 2 cm (1 in x ¾ in)

While blue-and-white porcelain is an iconic Chinese style, Peranakan porcelain typically features vibrant colours and intricate patterns. Annabel's work often combines these two historical styles with her own designs to create uniquely contemporary pieces that celebrate her cultural identity and experience.

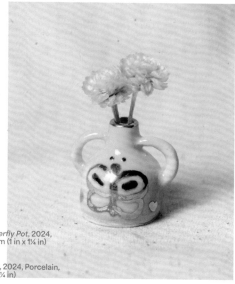

THIS PAGE
Lunar New Year Butterfly Pot, 2024, Porcelain, 2 cm x 3 cm (1 in x 1¼ in)

OPPOSITE
Lunar New Year Vase, 2024, Porcelain, 2.5 cm x 3 cm (1 in x 1¼ in)

Bx Woo

Bx Woo, also known as Wode Ceramics, is a Singaporean-born artist who makes 'dreamscapes and non-ingestible confections'. Her pottery is often finished with pastel hues and soft rainbow gradients, which transport viewers to a realm of whimsical imagination.

Bx's experience with miniature ceramics began when she visited Jingdezhen in China. After shadowing one of the pioneers of mini pottery in the region, Bx specialised in the same niche. She now works predominantly in porcelain and is always experimenting with new styles and techniques that push her to challenge the medium's boundaries. Bx describes herself as both 'technical and haphazard', and her works demonstrate the possibilities of accidental discoveries.

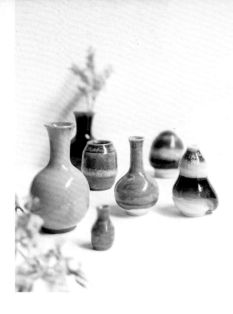

ABOVE
Wode Ceramics 1st Minis Collection, 2019, Porcelain and red clay, Largest piece 2.5 cm (1 in) tall

OPPOSITE
Stairway to Heaven Collection, 2021, Coloured porcelain, Largest piece 6 cm (2¼ in) tall

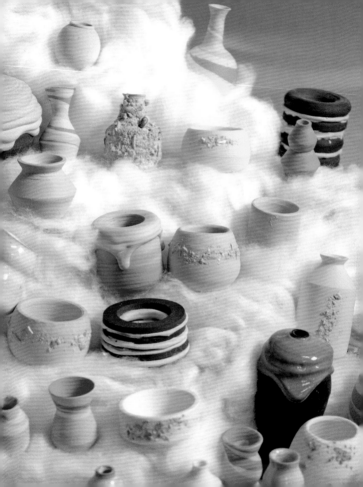

Since 2021, Bx has been travelling the globe to deepen her 'research and understanding of ceramics around the world'. This has led her to teach ceramic masterclasses and workshops to audiences from a range of backgrounds, which forms a core part of her work today. She also recently launched The Wheelie, a small portable pottery wheel with a high torque, catered to both hobbyists and professional artists.

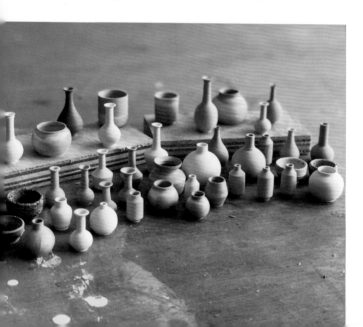

OPPOSITE
Stairway to Heaven Collection, 2021, Coloured
porcelain, Largest piece 8 cm (3¼ in) tall

BELOW
Rainbow Gloop Mini, 2021, Coloured porcelain,
3 cm (1¼ in) tall

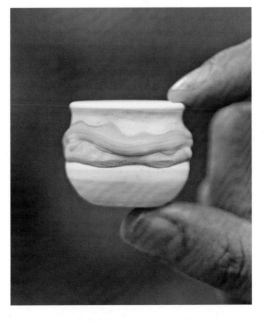

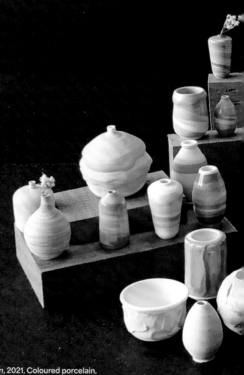

Rainbow Gloop Collection, 2021, Coloured porcelain,
Largest piece 6 cm (2½ in) tall

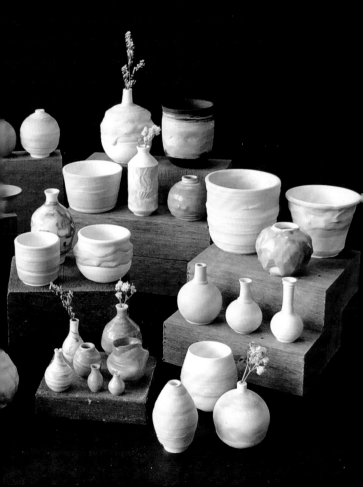

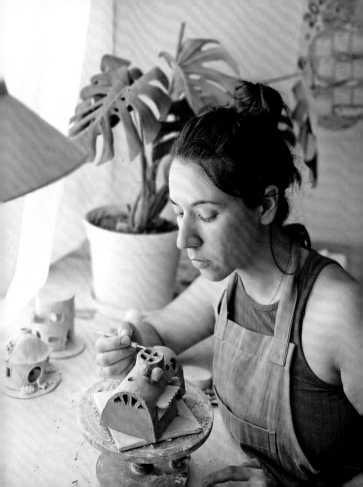

Carolina Platas

Carolina Platas is an artist from Buenos Aires, Argentina, who works under the name Aww Mini. She first ventured into ceramics six years ago after making custom pet portraits out of epoxy. Carolina wanted to create more 'long-lasting and utilitarian pieces', and ceramics were the natural next step in her creative journey.

An extension of Carolina's background in graphic design and illustration, her ceramics share the same sense of storytelling and whimsy – with an eye for detail. Animals remain a central feature of her creative practice: 'I've always found animals really interesting to observe and portray.' From sleepy tigers to capybaras taking a bath, many of her ceramics feature a depiction of wildlife that is infused with imagination and play.

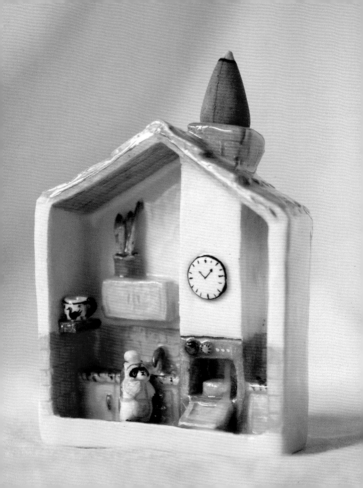

OPPOSITE
 Mapache Cocinero (Racoon Cook), 2022,
 Earthenware, 9 cm (3½ in) tall

BELOW
 Carpinchos (Capybaras), 2022,
 Earthenware, 7 cm (2¾ in) tall

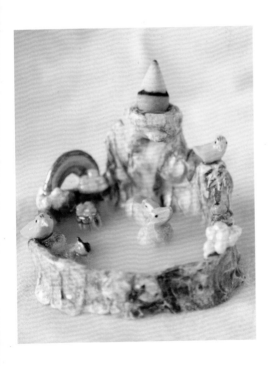

For Carolina, one of the most enduring aspects of working with miniatures is the ability to 'contain small worlds within our hands'. As a young mother with a toddler, her miniatures also have a practical benefit, as they allow her to work in a small space, a few hours at a time.

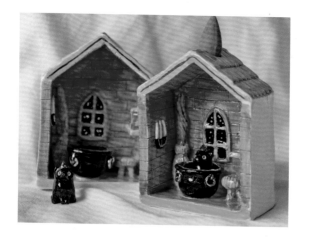

ABOVE
Gato de Bruja (Witch Cat), 2021,
Earthenware, 9 cm (3½ in) tall

OPPOSITE
Cajitas (Little Boxes), 2022,
Earthenware, 8 cm (3¼ in) tall

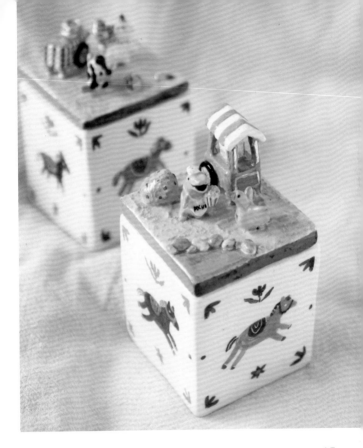

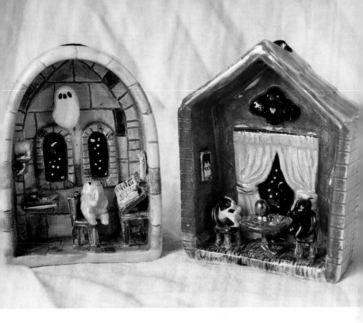

OPPOSITE
 Circo Animal (Animal Circus), 2023, Earthenware,
 9 cm (3½ in) tall

ABOVE
 *Sapo en Scriptorium & Gato Vidente (Toad in
 Scriptorium & Seer Cat)*, 2022, Earthenware,
 9 cm (3½ in) tall

Ceremony Studio

Karen Chung and Stephanie Hsie first met in 2018 at a community centre for ceramics. After admiring each other's work from afar, they started collaborating by creating 100 teacups to 'celebrate our Asian heritage'. Today, the two work together as Ceremony Studio, making ceramics inspired by their 'desire for people to find ceremony in the mundane'.

Among Ceremony's ceramics are a number of miniature ornaments and wall hangings that evoke shared meals and the cultural connection between food, people and place. Drawing inspiration from both Chinese and Korean cuisine - including dim sum and KBBQ - these pieces 'portray the dizzying array of dishes and beverages' to 'encapsulate a special scene'.

Ceremony's attention to detail, seen in the rims of plates and the edges of lettuce leaves, make their miniature meals come to life. For Karen and Stephanie, these details are both a testament to the beauty and presence found in 'daily tasks and rituals', and a celebration of diasporic Asian cultures.

BELOW
Holiday Ornaments, 2022, Stoneware, Largest piece 1 cm x 4.5 cm (½ in x 1¾ in)

OPPOSITE
Holiday Ornaments, 2022, Stoneware, Largest piece 1 cm x 4.5 cm (½ in x 1¾ in)

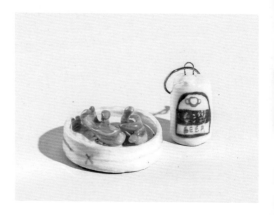

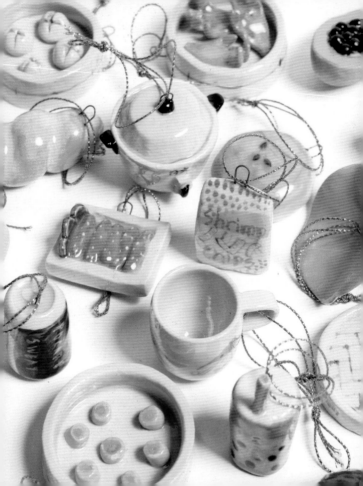

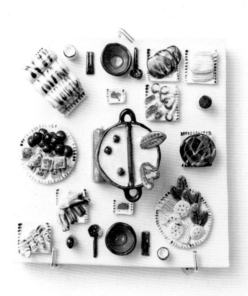

Butane Can Can, 2022, White earthenware,
25 cm x 25 cm (10 in x 10 in)

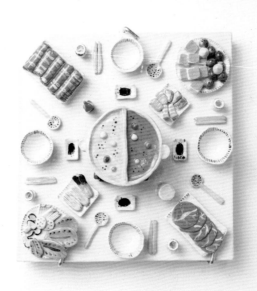

Butane Can Can, 2022, White earthenware,
25 cm x 25 cm (10 in x 10 in)

THIS PAGE
Chopstick Holder, 2022, Stoneware,
0.5 cm x 3.5 cm (¼ in x 1½ in)

OPPOSITE
Have You Eaten Yet, 2024, White earthenware,
25 cm x 25 cm (10 in x 10 in)

54

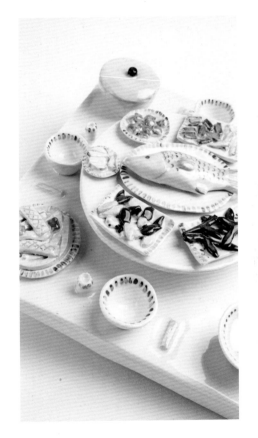

Cielo Vianzon

Cielo Vianzon's life-long obsession with dollhouse-scale miniatures led to her work in ceramics. She is an entirely self-taught potter: she learnt from online video tutorials, applying their techniques to make vessels on a tiny wheel.

Today Cielo works under the name Clayful Mini Ceramics and is best known for her contemporary style, which mixes and matches different shapes and influences. This includes vases, as well as functional mini lamps with a ceramic base and LED light.

Cielo primarily makes her work for other 'tiny lovers - mostly miniature enthusiasts, collectors and fellow miniature makers', as well as those who use the pieces as dollhouse accessories.

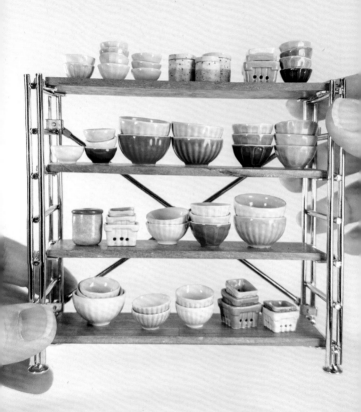

Almost all her ceramics are made to the standard 1:12 or 1:6 dollhouse scales: this presents the additional challenge of making each piece true to scale, as they may be displayed alongside other miniature objects. In Cielo's work, balance and proportion is essential to maintaining the illusion.

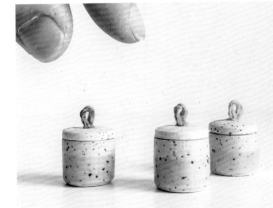

OPPOSITE
Petite Kitchen, 2023, Earthenware,
Largest piece 1 cm x 2.5 cm (⅖ in x ⅞ in)

ABOVE
Cookie Jars, 2023, Stoneware,
2 cm x 1 cm (¾ in x ½ in)

59

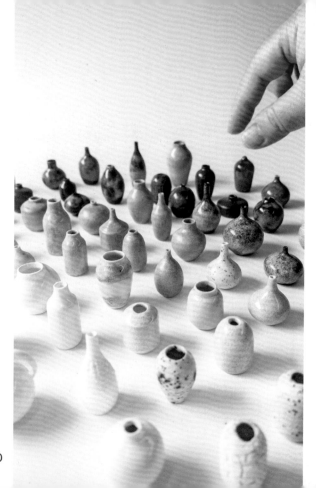

OPPOSITE
 Line Them Up, 2022, Stoneware and porcelain,
 Largest piece 3.5 cm x 2 cm (1½ in x ¾ in)

BELOW
 Let There Be Light, 2023, Stoneware,
 Largest piece 2.5 cm x 1 cm (1 in x ½ in)

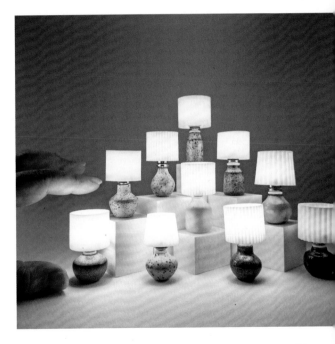

BELOW
Mix & Match, 2023, Earthenware,
Largest piece 2.5 cm x 1 cm (1⅛ in x ½ in)

OPPOSITE
Perfect Shelfie, 2022, Stoneware,
Largest piece 3 cm x 1 cm (1¼ in x ½ in)

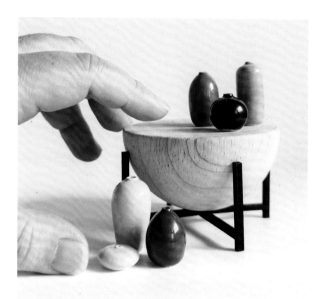

Claire Pareroultja

Hermannsburg Potters is a group of Western Arrarnta artists in central Australia, who create vibrant, brightly painted ceramic pieces based on their lived histories and culture.

Claire Pareroultja joined the centre in 2019, after spending many years painting in art centres in Western Australia and Tjuwanpa in her Country, Ntaria (pronounced: in-daria). She comes from a family of painters, including uncles Edwin and Reuben Pareroultja of the Hermannsburg School, who taught her watercolour painting. She says of this family connection: 'They learn me to paint landscape with watercolour, but now I paint on pottery.'

65

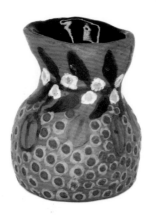

Langkwa (Bush Banana) Bush Foods Jug,
2022, Terracotta, 9 cm x 8 cm (3½ in x 3¼ in)

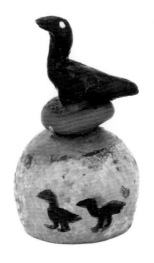

Ilia (Emu), 2023, Terracotta,
9 cm x 5 cm (3½ in x 2 in)

At Hermannsburg, Claire enjoys working on a miniature scale: 'I just make little small ones with my hand.' When she joined the studio, she says, 'I was feeling good to make little ones, you know, happy, excited to make little ones.'

Claire thinks about her grandparents when she makes her pots, and sharing her connection to place, her Country: 'I make stories about my father's Country, about my mother's Country and story about my life. I make it about bush tucker, bush flowers, all these stories so that everybody can see my Country.'

LEFT
For Witchetty Grub, 2023, Terracotta,
8 cm x 5 cm (3¼ in x 2 in)

OPPOSITE
Kara-arra (Kangaroo), 2023, Terracotta,
10 cm x 8 cm (4 in x 3¼ in)

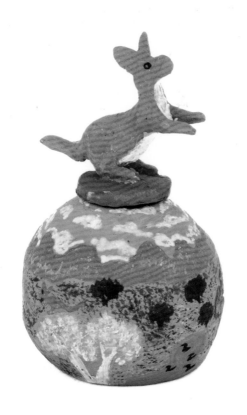

69

Waiting for a Fish, 2023, Terracotta,
6 cm x 6 cm (2½ in x 2½ in)

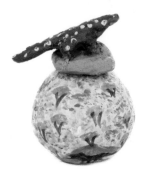

Ramia (Goanna), 2023, Terracotta,
6 cm x 5 cm (2½ in x 2 in)

Eleonor Boström

Eleonor Boström makes works inspired by her beloved childhood dog, Tess - a Petit Basset Griffon Vendéen. Like Tess, Eleonor's ceramic dogs are small in appearance but have a larger-than-life personality.

Eleonor started making miniature ceramics after a special one-off commission. The tiny pieces reminded Eleonor of her childhood knick-knacks, and she enjoyed the process of miniaturisation so much, she continued her small-scale work alongside her range of functional ware.

All her porcelain dogs are meticulously hand-painted using a magnifying glass and an ultra-mini brush. While this process challenges Eleonor's eyesight ('it's a finicky process'), it also means each of her porcelain dogs is uniquely detailed with an expressive face.

Working on a miniature scale allows Eleonor to test out new ideas, offering a chance to break with the expectations of full-scale work. She sees her miniatures as an 'exception, purely for fun'. When not in her studio, Eleonor gains inspiration from trawling flea markets in her neighbourhood and watching dogs along San Francisco's Ocean Beach.

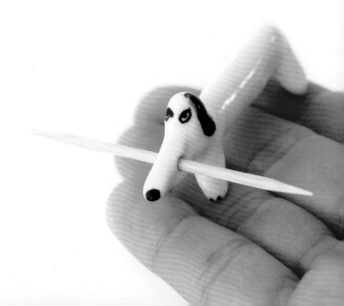

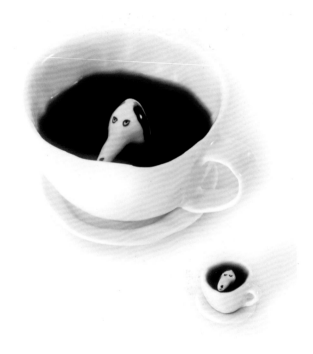

OPPOSITE
Mini Toothpick Dog, 2024, Paper porcelain,
2.5 cm x 5 cm (1 in x 2 in)

ABOVE
Dog in a Cup & Mini Dog in a Cup, 2024, Paper
porcelain, Largest piece 8 cm x 10 cm (3¼ in x 4 in)

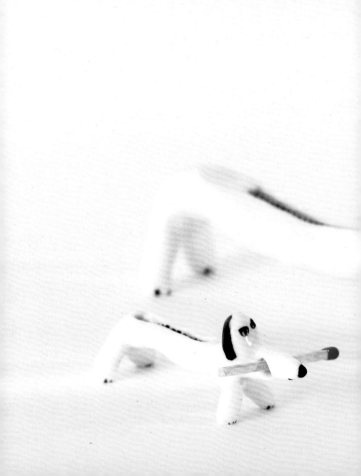

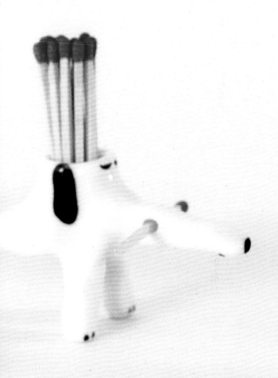

Matchstick Dog & Mini Matchstick Dog, 2024,
Paper porcelain, Largest piece 6 cm x 12 cm (2½ in x 4¾ in)

Fung Wing Yan

With a background in visual arts, Fung Wing Yan 馮穎恩 makes ceramics inspired by life, nature and the everyday, under the artist name Fungtaitau.

Fung started working with clay because she enjoys the process of turning her illustrations into practical objects; this includes painting on functional items, such as plates and cups, in order to bring cheer to their daily use.

Working on a miniature scale affords Fung the chance to create her 'own universe' that she can put in her pocket 'to take anywhere'. Among Fung's most recognisable characters are her miniature, rounded children and animals, which share a simplistic yet cheerful style. With curious faces, these figures express a sincerity and innocence, engaged in everyday activities.

According to Fung, her works are made for 'people who have a soft heart or those living along with their inner child'. She says that if everyone had a superpower, hers would be the ability to 'make you feel warm like a morning sun'.

OPPOSITE
 Cat Toy, 2023, Stoneware,
 Largest piece 3.5 cm x 3.5 cm
 (1½ in x 1½ in)

BELOW
 The Magician Ori, 2023, Stoneware,
 Largest piece 3.5 cm x 3.5 cm
 (1½ in x 1½ in)

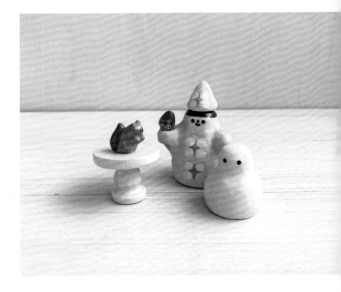

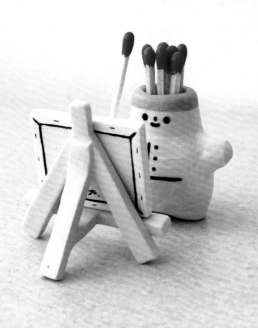

The Matchstick Painter, 2021, Stoneware, Largest piece 3.5 cm x 3 cm (1½ in x 1¼ in)

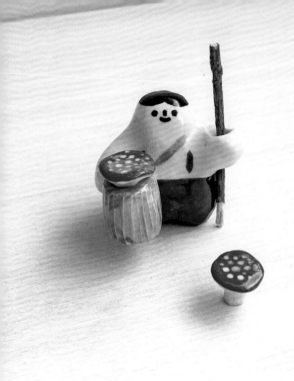

The Forest Boy, 2023, Stoneware, 3.5 cm x 3.5 cm (1½ in x 1½ in)

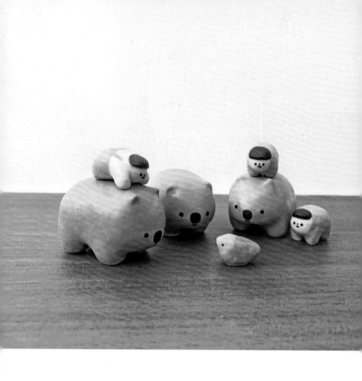

OPPOSITE
 Wombats and Friends, 2022, Stoneware,
 Largest piece 2.8 cm x 4.3 cm
 (1¼ in x 1½ in)

BELOW
 The Mushroom Set, 2023, Stoneware,
 4 cm x 3.3 cm (1½ in x 1¼ in)

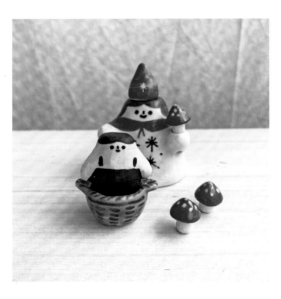

Grace Brown

Inspired by an interest in 'dislocated civilisations, lost cities and science fiction', Grace Brown creates ceramics that transport the viewer to an imaginary world, under the name Oh Hey Grace.

Spanning sculptural and functional pieces, her work features distinct geometric shapes and architectural motifs including stairways, domes, doorways, windows and bridges. These forms are derived from both real and imagined architecture, guided by an intuitive process of hand-building.

Among the challenges Grace faces working on a miniature scale are sharp corners and complicated joinery - and not having tools small enough to achieve the desired effect. This has resulted in creative problem-solving and crafting tools to carve clay and create smooth, crisp lines.

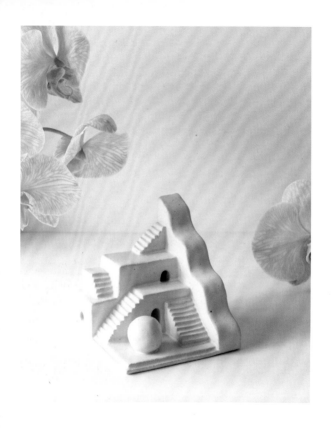

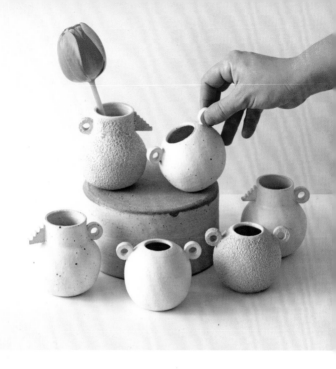

OPPOSITE
All Roads Lead Here, 2023, Mid-fire clay,
9 cm x 9 cm (3½ in x 3½ in)

ABOVE
Mini Orb Vessels, 2022, Mid-fire clay,
9 cm x 7 cm (3½ in x 2¾ in)

89

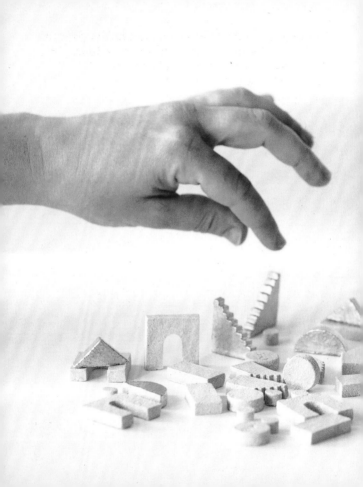

Grace prefers to work in a muted colour palette, allowing the clay's natural hue and texture to shine. This choice also reflects the subject matter she explores, her ceramics mimicking the appearance of stone and other natural building materials. In this way, each of her works invites imaginary play and contemplation of 'another time, place or universe'.

Golden Miniature Building Blocks, 2023, Mid-fire clay, Largest piece 2.5 cm x 5 cm (1 in x 2 in)

Hamish Bassett

Hamish Bassett, working under the moniker Tiny Pots Melbourne, started creating miniature ceramics in 2020 after realising how much he enjoyed making tiny pots and gifting them to friends.

With a background in 3D animation, Hamish brings an eye for detail and a meticulousness to his ceramics, which are all thrown on a miniature pottery wheel with stoneware or porcelain.

Despite the small size of his works, Hamish expresses that it's important for him that they maintain their functionality: 'that the lids and spouts work properly', or that vases are 'able to hold a twig or a whisker or a sprig of dried flowers'.

ABOVE
Polka Dot Tea Set, 2024, Stoneware,
2.8 cm x 3.8 cm (1¼ in x 1½ in)

OPPOSITE
Untitled, 2022, Stoneware,
Largest piece 3.2 cm x 2 cm (1¼ in x ¾ in)

Whether it's a miniature teapot, teacup, vase or jug, each of his pieces precisely transposes the techniques and components of their full-sized counterparts.

This careful attention demonstrates the delicate touch required to create miniatures, but also imbues every piece with a sense of wonder and whimsy. For Hamish, this is what he enjoys most about working on a tiny scale - the ability to evoke a 'childlike sense of playfulness and creativity', no matter your age.

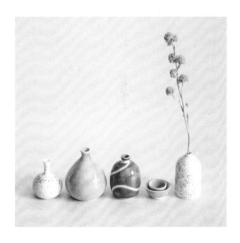

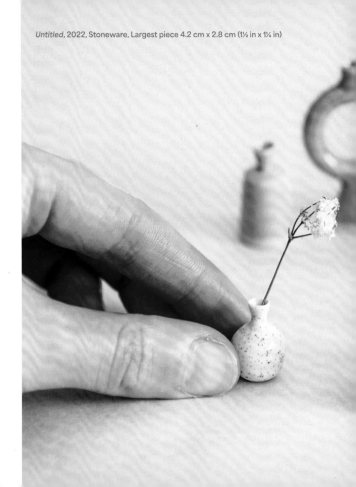

Untitled, 2022, Stoneware, Largest piece 4.2 cm x 2.8 cm (1½ in x 1¼ in)

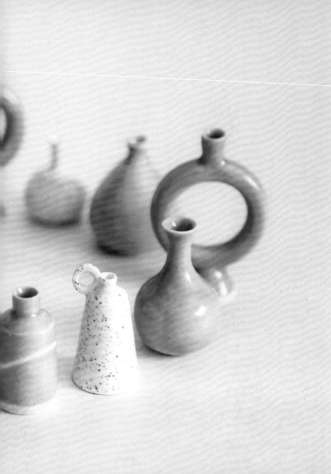

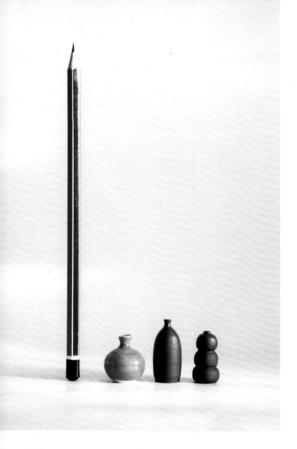

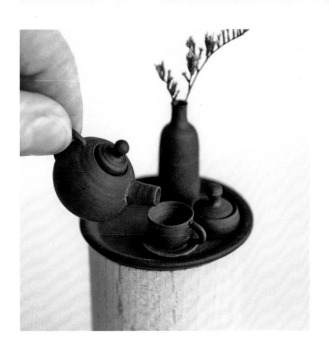

OPPOSITE
Untitled, 2022, Stoneware and mid-fire clay,
Largest piece 3.5 cm x 1.5 cm (1½ in x ½ in)

ABOVE
Black Tea Set, 2023, Mid-fire clay,
3.5 cm x 4 cm (1½ in x 1½ in)

Hannah Billingham

Hannah Billingham taught herself to throw on the wheel after doing a foundational degree in ceramics.

Today, she works from a commercial studio space in Middleton-on-the-Wolds, creating ceramics with a distinctive 'dotted' appearance. Her work pairs finely shaped, bulbous vessels with a surface texture of raised all-over spots.

With a passion for glaze chemistry, Hannah spends a lot of her time in the studio developing new glazes from raw materials to emphasise the delicate surfaces of her ceramics. Many are finished with a golden lustre, which makes each individual piece shine like a jewelled Fabergé egg.

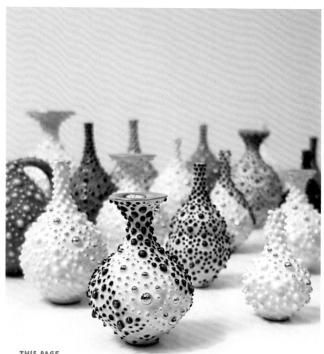

THIS PAGE
Black & White Vase, 2020, Stoneware,
4 cm x 3 cm (1½ in x 1¼ in)

OPPOSITE
A Collection of Five Miniatures, 2021, Stoneware,
Largest piece 6.5 cm x 3.5 cm (2½ in x 1½ in)

Hannah's ceramics are a creative outlet that allows her the space to cope with her OCD and desire for order amid the 'chaotic reality of life'. Working with clay and kilns is a constant push and pull of precision and unpredictability, and miniatures provide 'no room for error' as the whole work is perceivable at a glance. The scale is a challenge, but Hannah enjoys the idea that each piece expresses a 'complete idea in the palm of [her] hand': that she can capture something big in something so small.

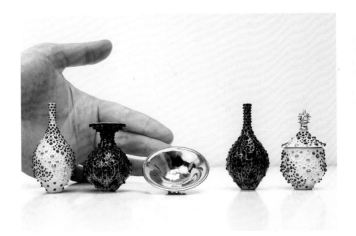

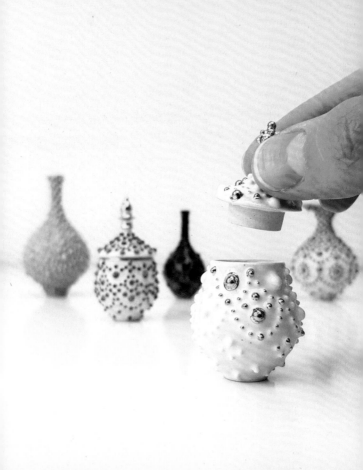

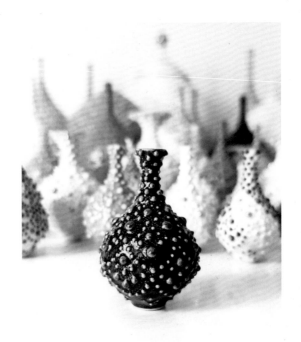

OPPOSITE
A Collection of Five Miniatures, 2021, Stoneware,
Largest piece 6.5 cm x 3 cm (2½ in x 1¼ in)

ABOVE
Blueberry Vase, 2020, Stoneware,
4.5 cm x 3 cm (1¾ in x 1¼ in)

Hui-Yong Ford

Hui-Yong Ford 김희영 started making ceramics in 2008, after a workshop piqued her interest. Under the name Galaxy Clay, she works with lustrous mother-of-pearl glazes and hand-painted finishes that give each of her pieces a 'mysterious opalescent light', the finished ceramics resembling celestial skies.

Many of Hui-Yong's works use raku firing to great effect, whereby pieces are removed from the kiln while still scorching hot before being cooled rapidly to create a unique finish.

Hui-Yong cites Korean ceramics as her main inspiration. Her vessels are an homage to traditional buncheong (celadon ware dipped in white slip) and maebyeong (plum bottles). These references are reflected in Hui-Yong's use of voluptuous lines, curved contours and finishes.

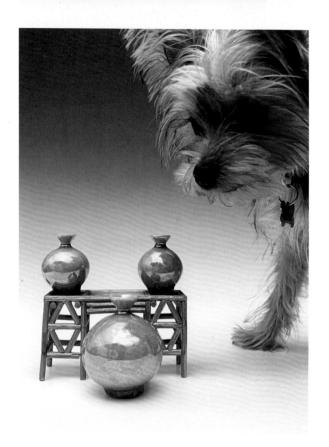

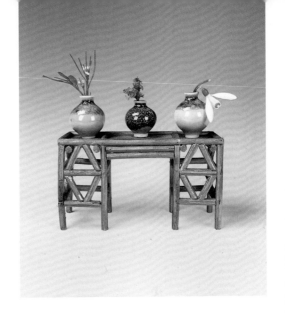

OPPOSITE
 Bébé Blue, 2023, Porcelain,
 Largest piece 6.3 cm x 5.4 cm (2½ in x 2¼ in)

ABOVE
 Purple Rain, 2022, Porcelain,
 3.2 cm x 2.5 cm (1¼ in x 1 in)

In contrast to some miniature ceramicists, Hui-Yong makes her small works on a standard-sized pottery wheel, adapting her hand pressure and using her fingertips more frequently to shape the pieces. She works with porcelain as a blank canvas, and uses painting, water etching, slip trailing and more to express the beauty found in nature.

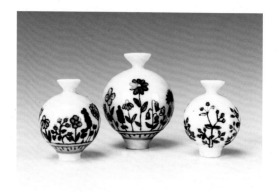

ABOVE
Blooming Beauties, 2021, Porcelain,
Largest piece 5.2 cm x 3.3 cm (2 in x 1¼ in)

OPPOSITE
Oyster's Pride, 2022, Porcelain,
4.5 cm x 4 cm (1¾ in x 1½ in)

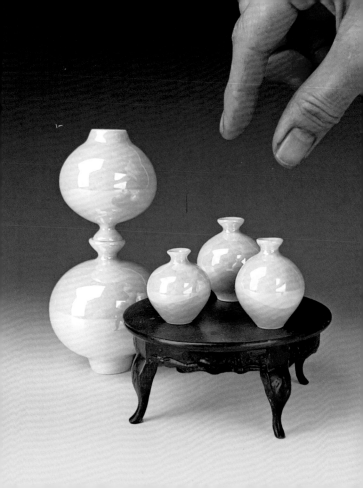

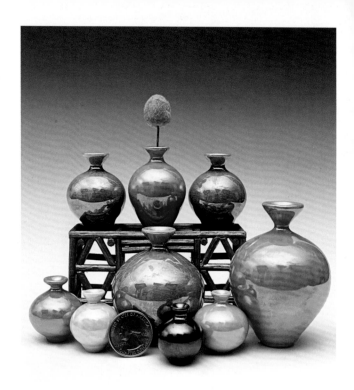

OPPOSITE
Miniature 3, 2023, Porcelain,
Largest piece 7.7 cm x 5.5 cm
(3 in x 2¼ in)

BELOW
Pot of Gold, 2021, Porcelain,
3 cm x 2.5 cm (1¼ in x 1 in)

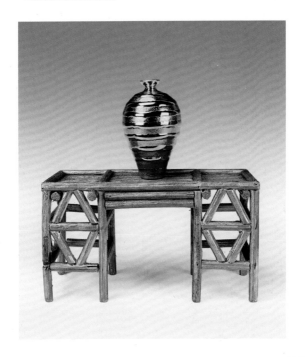

Hyeyoun Shin

Hyeyoun Shin 신혜연 moved from South Korea to the Gold Coast, Australia, with her family, where she picked up ceramics after visiting a pottery association seven years ago. Her small-scale work started from a pragmatic desire to reduce clay costs, but it quickly became a key component of her ceramics.

As reflected in Hyeyoun's working name, illy's wall, her miniature pieces are often made to be featured on the wall. This includes small vases affixed to ceramic frames, and mini windowsills and shelves that are attached to wall fixtures. Some of these pieces resemble still lifes, complete with mini books and small, dried plants.

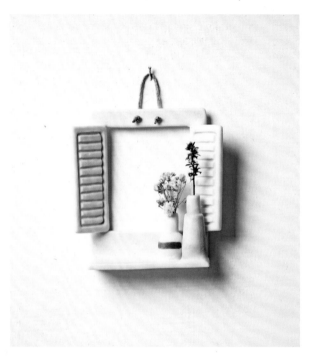

ABOVE
Window, 2023, Porcelain,
7.5 cm x 7.5 cm (3 in x 3 in)

OPPOSITE
Doll Vase, 2023, Porcelain,
Largest piece 8 cm x 2 cm (3¼ in x ¾ in)

Hyeyoun speaks about her interest in walls in relation to her migrant experience, moving from place to place. She recalls that the 'easiest and cheapest way to make the place feel like a home was putting old pictures of my friends or dried flowers on the wall'. In this way, Hyeyoun's works are, at heart, about the relationships between people and the objects around them, and the meanings made from these connections.

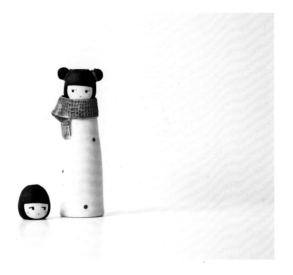

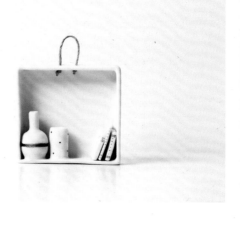

Bookshelf, 2024, Porcelain, 5.7 cm x 6.3 cm (2¼ in x 2½ in)

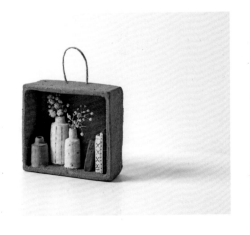

Stoneware Bookshelf, 2023, Dark stoneware, 6.2 cm x 7 cm (2⅛ in x 2¾ in)

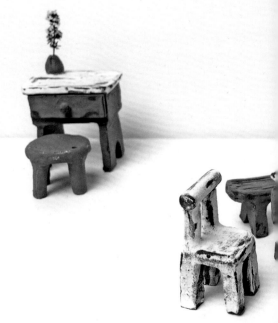

Desk and Dining Table, 2022, Chocolate brown,
Largest piece 6.5 cm x 7.5 cm (2½ in x 3 in)

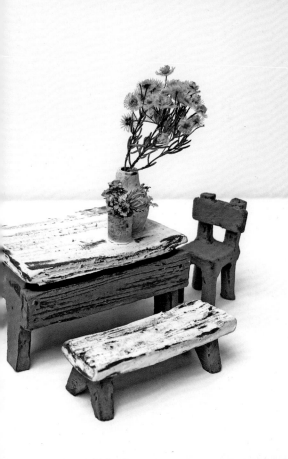

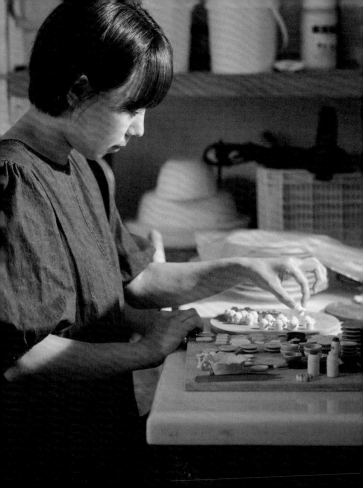

Jin Seon Kim

Jin Seon Kim 김진선, also known as KIDO, left her day job to pursue an art-related career. While considering different majors, she was drawn to ceramics because she liked working with her hands. After creating a dollhouse for her Degree Show ('[divided] into five rooms based on five concepts that represented different stages of my life'), miniature ceramics became a central focus for her.

Using a combination of wheel-throwing, slip-casting and hand-building, Jin Seon makes small ceramic scenes and objects that are inspired by vintage design and antique objects. She also draws particular influence from her childhood and retro advertising posters from the 80s and 90s that are characterised by 'bold and vivid colours'. Colour plays an important role in Jin Seon's works, often guiding their style.

ABOVE
Kiki's Drawer, Christmas Edition, 2021, White porcelain,
Largest piece 2.8 cm x 1.2 cm (1¼ in x ½ in)

OPPOSITE
Kiki's Drawer, Little Bunny Set, 2022, White porcelain,
Largest piece 2.6 cm x 1.3 cm (1 in x ½ in)

For Jin Seon, her works appeal to the 'kidult' – that is, 'adults who are seeking an escape from the monotony of daily life'. Her intention is to highlight, through ceramics, the happiness that can be attained from focusing on smaller joys.

OPPOSITE
Kiki's Drawer, Picnic Set, 2023, White porcelain,
Largest piece 1.7 cm x 2.5 cm (¾ in x 1 in)

BELOW
Kiki's Drawer, Teddy Bear Set, 2021, White porcelain,
Largest piece 2.5 cm x 1.5 cm (1 in x ½ in)

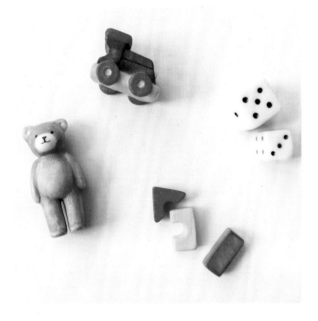

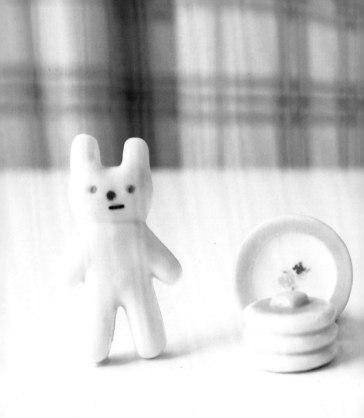

Kiki's Drawer, Little Bunny Set, 2022, White porcelain, 2.5 cm x 1.5 cm (1 in x ½ in)

Kaley Flowers

Kaley Flowers' works are inspired by Internet culture and aesthetics, and the societal impacts of digital technologies on people and nature.

Her large and small creations, which include ceramic laptops and functional USB sticks, capture the ephemeral nature of our digital lives through the permanence of clay. Layered with digital nostalgia and iconography, Kaley's art has broad appeal for Gen Z and millennial audiences who identify with her work's visual touchstones.

For Kaley, clay is a material with a loaded cultural history, and its use can take on many forms and meanings that are endlessly fascinating.

Kaley enjoys working on a miniature scale as it allows her to experiment with ideas in a low-risk manner; she reflects that, in addition to a sense of fun, miniature works present 'less pressure to get everything perfect' – a great chance to test glazes and new techniques. This includes the layering of glazes and multiple firings in the kiln to create a 'melted' effect, and the mixing of clay and found materials such as resin and mirrors.

Tommy Hat, 2020, Stoneware, 5 cm x 5 cm (2 in x 2 in)

LEFT
Bugbyte USB, 2023, Stoneware,
3 cm x 7 cm (1¼ in x 2¾ in)

ABOVE
Wishing W3ll, 2019, Stoneware,
10 cm x 5 cm (4 in x 2 in)

133

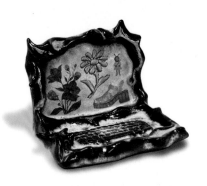

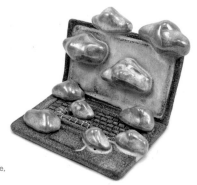

ABOVE
Jelly Tech, 2023, Stoneware,
7.5 cm x 10 cm (3 in x 4 in)

RIGHT
Cloudscape, 2024, Stoneware,
6 cm x 10 cm (2½ in x 4 in)

OPPOSITE
Sabrina, 2023, Stoneware,
17.5 cm x 22.5 cm (7 in x 9 in)

134

Kate Schroeder

Kate Schroeder's interest in miniatures – and her love for making them – started in childhood.

As a kid in Missouri, she made tiny objects for her dollhouse out of polymer clay. When she later pursued an MFA in sculpture, her professors pushed her towards monumental works, but she retained an interest in small-scale art due to its ability to create a 'unique connection and intimacy with the viewer'.

This emotional connection still guides Kate as she works at the intersection of miniature ceramics and functional art today. For Kate, her decision to 'persist in prioritising functionality' is a deliberate challenge to the art/craft divide: one that allows her to 'navigate the fine line' between the two.

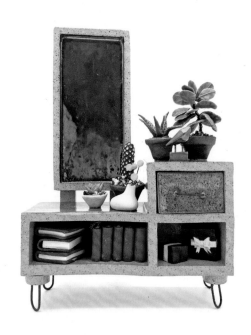

ABOVE
Jewelry Box Vanity, 2023, Stoneware and porcelain,
Largest piece 12.5 cm x 10 cm (5 in x 4 in)

OPPOSITE
Mondrian Pattern Mini Malm Burner and Accessories, 2023,
Stoneware, Largest piece 22.5 cm x 10 cm (9 in x 4 in)

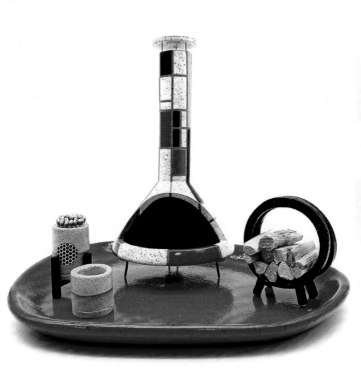

Kate specialises in slab-building, creating a vast range of objects, such as miniature shelves, plants, furniture and Mini Malm Burners (reproductions of mid-century modern fireplaces), from stoneware and porcelain. Her works are inspired by the comforts of domestic spaces and the objects we choose to fill our lives with. She describes her choice of subject as a reflection of the 'emotional impact of collecting objects'.

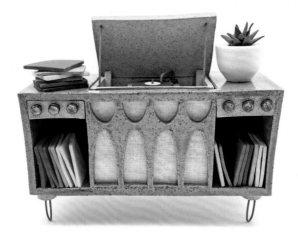

OPPOSITE
Broyhill-inspired Record Console,
2023, Stoneware and porcelain,
10 cm x 15 cm (4 in x 6 in)

BELOW
A Time for Comfort and Solitude,
2024, Stoneware and porcelain,
42 cm x 24 cm (16½ in x 9½ in)

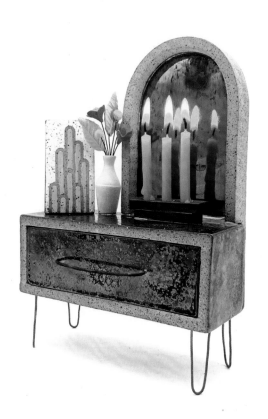

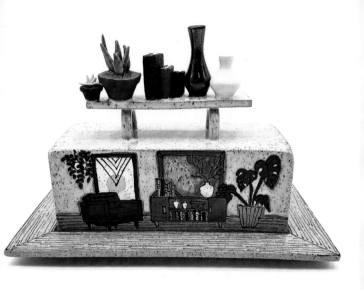

OPPOSITE
Miniature Candle Holder Dresser, 2023, Stoneware and
porcelain, 12.5 cm x 10 cm (5 in x 4 in)

ABOVE
Shelfie Butter Dish, 2023, Stoneware and porcelain,
16.5 cm x 25.5 cm (6½ in x 10 in)

143

Keiko Matsui

Keiko Matsui マツイ ケイコ is a Japanese-born ceramicist living in Melbourne, Australia who works across functional and decorative porcelain. A part of her larger practice, Keiko started making miniatures 17 years ago as a 'playful endeavour', crafting both small chairs and houses.

Each chair and house is hand-sculpted; the chairs are formed from a solid clay ball to ensure firm connections to each leg, while the houses are built up with porcelain to allow a slower drying time. Each piece is then decorated with fine lines, dots and other painted details, the embellishments giving the chairs and houses their individual characteristics. In this way, they represent not only a space to relax or be, but also individual people's narratives and experiences.

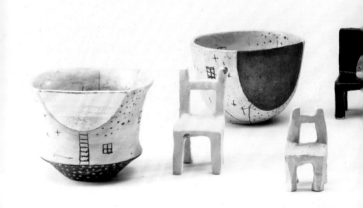

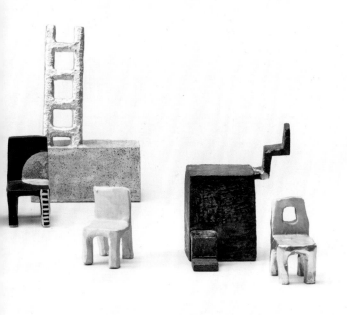

To the Half Moon, 2016, Stoneware, Largest piece 18 cm x 10 cm (7 in x 4 in)

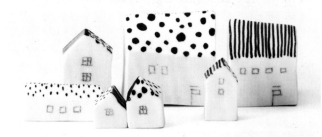

ABOVE
Blue and White Porcelain Houses, 2015,
Porcelain, 5 cm x 4.5 cm (2 in x 1¾ in)

OPPOSITE
Neko Chair 1 & 2, 2023, Stoneware,
10 cm x 4 cm (4 in x 1½ in)

Metaphorically, the chairs and houses reflect Keiko's own experiences as an immigrant - moving from country to country, house to house, seeking a place to live and settle down. Of their origin, Keiko says: 'I envisioned finding a place to settle - a space where I could place my favourite chair in my own home.' She further reflects, 'chairs symbolise a space to belong.'

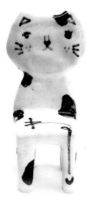
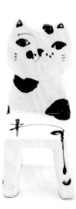

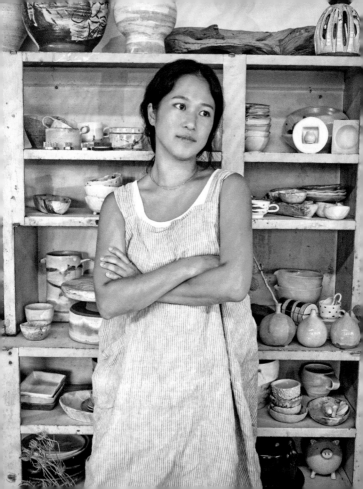

Kiley Seoyen Hwang

Since 2009, Kiley Seoyen Hwang 최서연 has been working with clay, making functional and decorative ware (both small and large) under the name Yenworks from her Los Angeles studio.

Among Kiley's miniature repertoire are small vessels inspired by Korean and Japanese ceramics, informed by a childhood spent in both countries. This influence can be clearly seen in her mini moon jars and maebyeong (plum bottle)-inspired works, as well as her use of glazes to create a 'wabi-sabi' effect that highlights the beauty of imperfections.

Kiley enjoys working with miniature ceramics, as they are 'simply so fun to make'. She describes how their small scale means the 'most ordinary, unnoticeable flowers or plants look special' when placed inside, and that when the pieces are lined up, they create 'their own world'. In this way, Kiley's ceramics invite us to re-examine our everyday life, bringing joy and beauty to the ordinary.

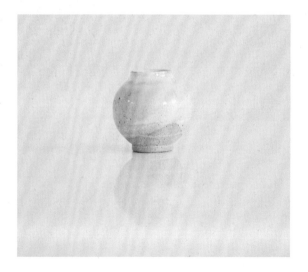

Untitled, 2022, Porcelain, 5 cm x 3 cm (2 in x 1¼ in)

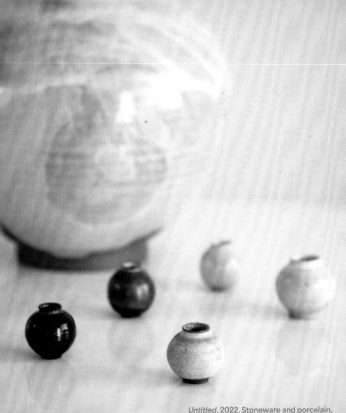

Untitled, 2022, Stoneware and porcelain,
Largest piece in forefront 5 cm x 3 cm (2 in x 1¼ in)

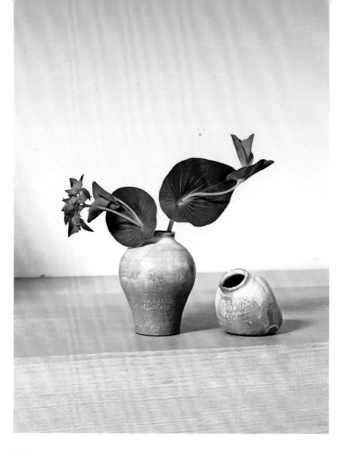

154

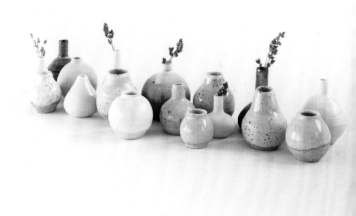

OPPOSITE
Untitled, 2022, Stoneware,
Largest piece 5 cm x 3 cm (2 in x 1¼ in)

ABOVE
Untitled, 2017, Stoneware and porcelain,
Largest piece 5 cm x 3 cm (2 in x 1¼ in)

Lucile Sciallano

Lucile Sciallano and Ben Landau co-founded Alterfact in 2014 to merge new technology and tradition through 3D printed ceramics.

Today, Lucile manually prepares fresh clay by hand for each unique print, working from a laptop linked up to a DIY printer ('not very technical compared to what you can buy now').

The questions that Lucile first explored through clay as a child have evolved with technology, as 3D printing invites new enquiries into the relationship between the hand and the machine. For Lucile, printing ceramics still relies on human control and precision, with constant adjustments made to the coil size and finished product. Working on a miniature scale prompts further challenges in terms of structural integrity, given the fragility of the coil.

At the heart of Lucile's recent works is an interest in the 'glitch', in the form of visual and structural disruptions. These are pre-emptively designed into the printing process, but also occur naturally through serendipity. After printing is complete, each piece is finished through drying, and bisque and glaze firing. It is here that Lucile uses colours and tones to further emphasise the interferences and imperfections.

ABOVE
Basket, 2024, Porcelain,
2.5 cm x 5.5 cm (1 in x 2¼ in)

OPPOSITE
Add Ons, 2024, Porcelain,
Largest piece 3.5 cm x 5.2 cm (1½ in x 2 in)

Nest, 2024, Porcelain, 2.2 cm x 2.1 cm (¾ in x ¾ in)

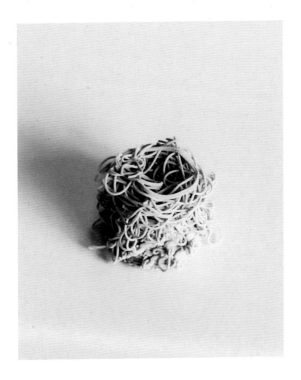

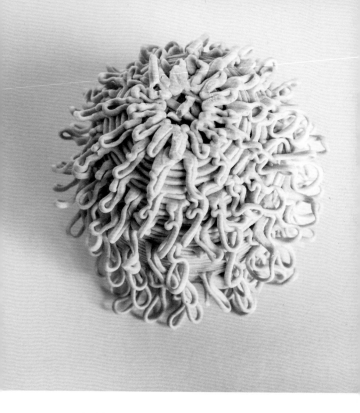

Don't Squeeze too Hard, 2024, Porcelain, 4.5 cm x 5.5 cm (1¾ in x 2¼ in)

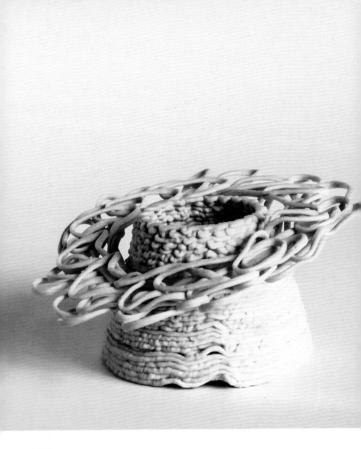

162

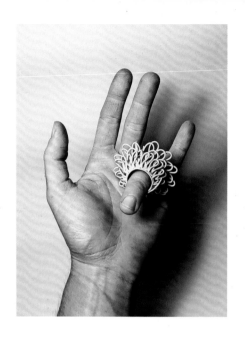

OPPOSITE
Little Opening, 2024, Porcelain,
2.5 cm x 5.5 cm (1 in x 2¼ in)

ABOVE
Ropes, 2024, Porcelain,
2.5 cm x 5 cm (1 in x 2 in)

163

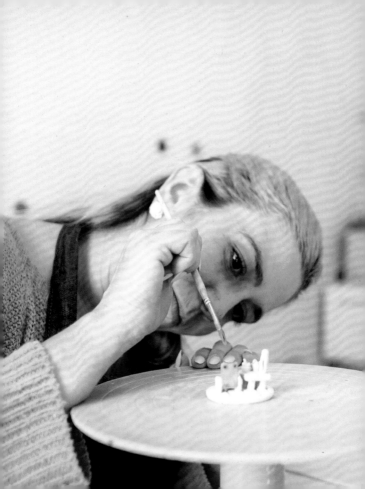

Mayra Luna

Mayra Luna, who makes ceramics under the name Salvi, has spent her whole life crafting things from clay. From a childhood workshop at the age of nine to high school studies through to a postgraduate degree, the medium has always mesmerised her.

Many of Mayra's pieces are small-scale dioramas or scaled-down scenes inspired by daily life, and many are clear visual nods to Polly Pocket – a treasured childhood toy that she always carried with her as a kid.

Making tiny house fittings and decorations requires a dexterity of hand as well as constant adaptation. One challenge of working on a miniature scale is that small pieces dry quickly, so pre-planning and control is essential to construction.

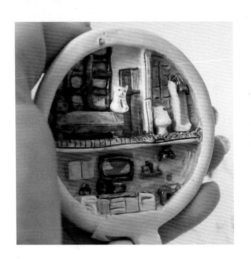

OPPOSITE
Salvi Poquet Corazon (Heart), 2023, Earthenware,
5.5 cm x 11 cm (2¼ in x 4¼ in)

ABOVE
Salvi Poquet Circulo (Circle), 2022, Earthenware,
8 cm (3¼ in)

167

For Mayra, the small scale of her work invites a range of feelings: 'a mix of surprise, tenderness and a desire to eat them'. The scale also invites a 'moment of intimacy with the object, as if it were telling a secret'. This personal connection is furthered through her custom work recreating house facades and interiors based on people's photos and memories.

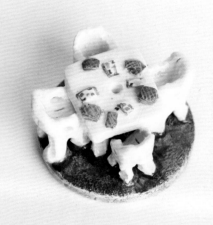

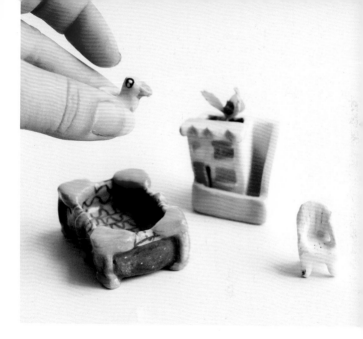

OPPOSITE
Mini Mesa de Truco (Mini Card Table), 2023,
Earthenware, 4.5 cm x 3.5 cm (1¾ in x 1½ in)

ABOVE
Plopchino y Phs Miniature (Pool and Apartment),
2022, Earthenware, Largest piece 9 cm x 9 cm
(3½ in x 3½ in)

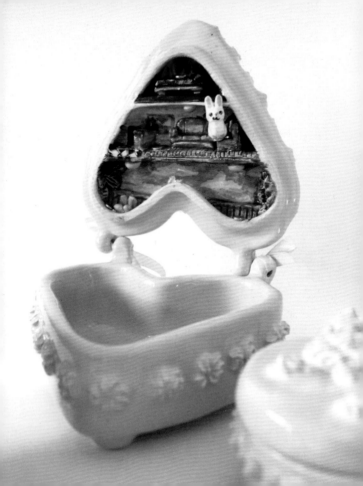

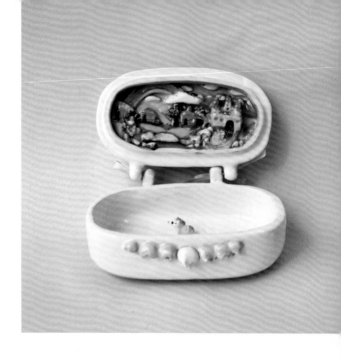

OPPOSITE
Salvi Poquet Corazon (Heart), 2023,
Earthenware, 5.5 cm x 11 cm (2¼ in x 4¼ in)

ABOVE
Salvi Poquet Pasty (Tablet), 2023,
Earthenware, 5.5 cm x 16.5 cm
(2¼ in x 6½ in)

171

Melodie Kwong

Melodie Kwong took a ceramics course in 2019, after failing to find a cute planter for her personal use. She quickly became hooked on working with clay, and soon started making and selling ceramics under the name Milkybon.

Melodie makes ceramics that are tinged with playfulness and childhood nostalgia: they draw visual inspiration from her childhood, as well as her East Asian cultural upbringing. This influence can be clearly seen in her use of a blue-and-white 'rice grain' pattern, a visual homage to the blue-and-white tableware commonly found in Chinese homes. Cultural influences are also clear in Melodie's choice of subject matter, ranging from her favourite Asian snacks to depictions of folklore and myths.

Among Melodie's miniature works are her ongoing series of 'potlings' - so-called portable, miniature vases, which allow the wearer to insert a flower or sprout of their choice. Designed at first to look like potion pots, Melodie later added small limbs and faces to each give potling a distinct character.

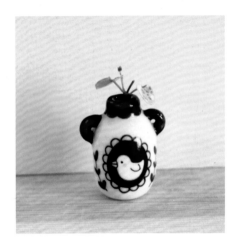

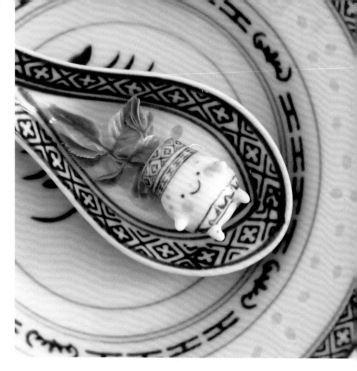

OPPOSITE
Duck Vase Magnet, 2022, Porcelain,
4 cm x 2.5 cm (1½ in x 1 in)

ABOVE
Rice Potling, 2021, Porcelain,
2.7 cm x 2 cm (1 in x ¾ in)

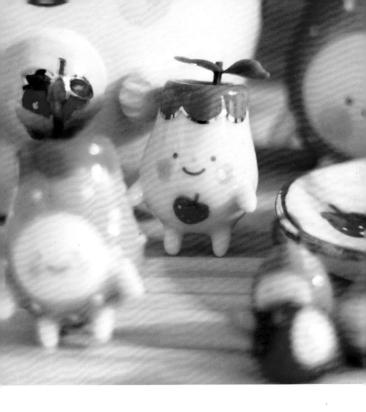

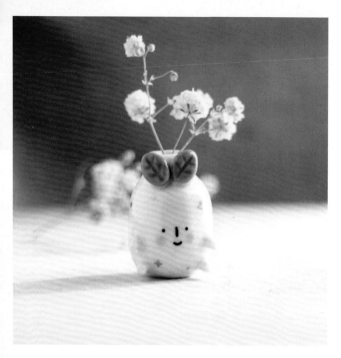

OPPOSITE
Strawberry Potling, 2022, Porcelain,
3 cm x 3 cm (1¼ in x 1¼ in)

ABOVE
Radish Vase, 2022, Porcelain,
2.5 cm x 2 cm (1 in x ¾ in)

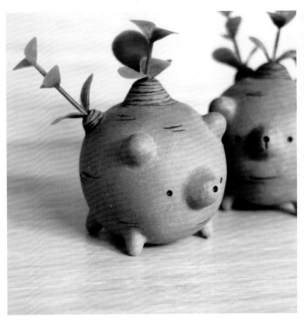

ABOVE
Stephania Bearecta, 2022, Stoneware,
6 cm x 5 cm (2½ in x 2 in)

OPPOSITE
Jade Rabbit Bracelet, 2023, Porcelain,
1.3 cm x 2 cm (½ in x ¾ in)

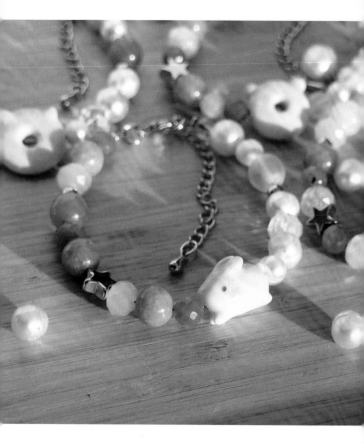

Milo Hachim

Milo Hachim is a Chilean artist working and living in Barcelona, Spain. She has a background in freelance illustration and design, and these influences are clear in her ceramics - both large and small.

From vases to sculptural pieces and figures, Milo's vivid and brightly coloured works feature an array of unique characters and settings sourced from popular culture and the everyday, which transport viewers into a radiant and joyous world. Milo creates works inspired by her love for 'details and cute things'. A common motif is books: a visual nod to childhood days spent following her father (a schoolteacher) to browse bookstore shelves.

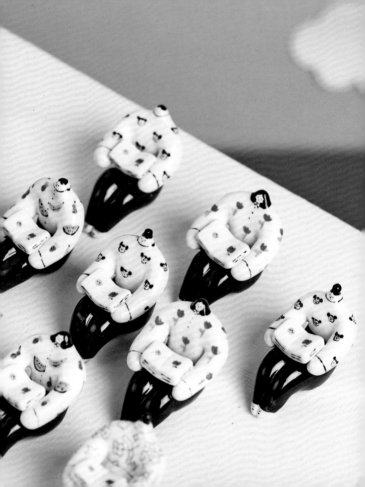

OPPOSITE
Mini Readers 1, 2022, Low-fire clay,
3.5 cm x 2.5 cm (1½ in x 1 in)

ABOVE
Mini Vase, 2022, Low-fire clay,
6 cm x 2.5 cm (2½ in x 1 in)

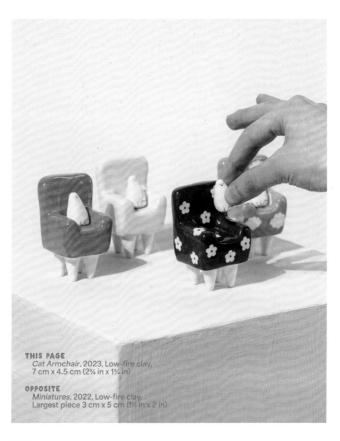

THIS PAGE
Cat Armchair, 2023, Low-fire clay,
7 cm x 4.5 cm (2¾ in x 1¾ in)

OPPOSITE
Miniatures, 2022, Low-fire clay,
Largest piece 3 cm x 5 cm (1¼ in x 2 in)

For Milo, the value of working on a miniature scale is the ability to 'achieve the synthesis of something complex at a small size'. The concentration and care she applies to each individual piece adds something special, and while this process can be difficult, it is also what Milo enjoys most about her work. All her ceramics are hand-modelled and painted, which gives each one a unique finish.

Mizuki Tanaka

Mizuki Tanaka, working under the name Tenko, creates art for those 'who can't sleep at night'. Her ceramics are dreamy concoctions that blur together nostalgic childhood memories, expressing 'the existence of another world, coexisting with ours'.

Mizuki started making ceramics during COVID-19 lockdowns, when university workshops and studios were closed for public access. Seeking ways to continue making art at home, she started creating clay forms by hand. Mizuki relishes the freedom hand-building ceramics offers. She says of the technique: 'It's a time when my confidence returns and I can genuinely enjoy the creative process, which is absolutely essential for me as an artist.'

Mizuki's ceramic works include functional objects, such as candlesticks and incense holders, as well as decorative pieces like dollhouses. Her visual language spans the bridge between surrealism and realism; while there are details that might be instantly recognisable, the works are 'free because it's fantasy'. She hopes that 'people who look at my artwork can find some peace of mind'.

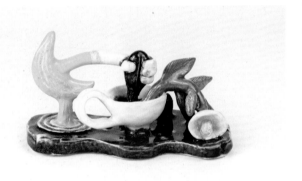

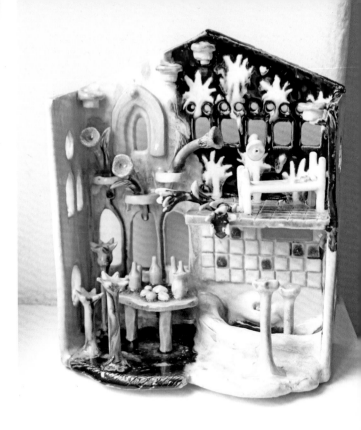

189

ABOVE
Incense Holder, The Cat in Love with the Goldfish, 2024, Stoneware,
5 cm x 10 cm (2 in x 4 in)

OPPOSITE
Incense Holder, If I See You in My Dream, 2024, Stoneware,
5 cm x 10 cm (2 in x 4 in)

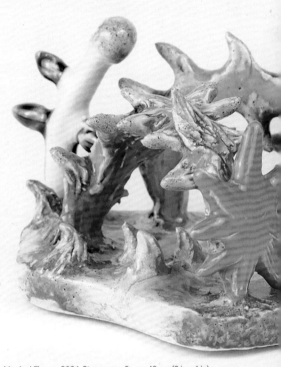

Incense Holder, Magical Flower, 2024, Stoneware, 5 cm x 10 cm (2 in x 4 in)

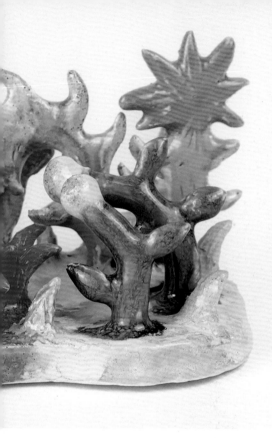

Noriaki Ichikawa

Noriaki Ichikawa was inspired by his grandfather, a pottery enthusiast, to start working with clay in 2004. Today, Noriaki continues to split his hours between an office job and ceramics, which he makes in his free time in a home studio.

While Noriaki started with regular-sized ceramics, he has since gained recognition for his functional miniature works. This includes his series of small teapots, designed to 'pour tea properly', as well as his small bonsai pots that are able to house live plants.

Noriaki enjoys not only the process of working on a miniature scale, but also creating custom crafting tools for this pursuit. This includes innovative use of everyday materials, such as repurposing the lid of a Pringles container into a makeshift bat for throwing pottery.

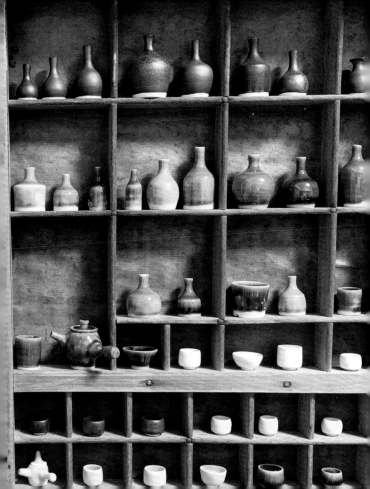

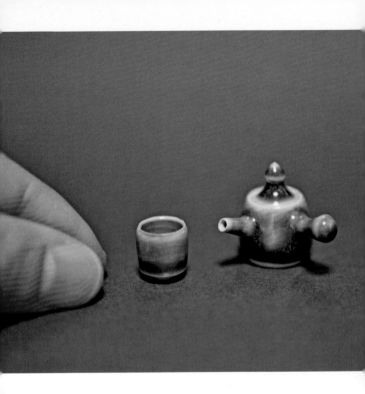

PREVIOUS PAGES
Little Pottery Pieces with an Antique Printer Tray, 2020,
Various clays, Largest piece 6 cm x 2.3 cm (2½ in x ¾ in)

OPPOSITE
Tiny Teacup and Teapot, 2020, Shigaraki clay,
Largest piece 2.5 cm x 2.5 cm (1 in x 1 in)

BELOW
Small Teapot, 2023, Black mud clay,
4.5 cm x 7 cm (1¾ in x 2¾ in)

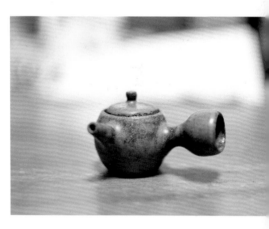

In 2017 Noriaki made his first miniature pottery wheel, its speed controlled with smartphones. This wheel, called Yubirokuro ('yubi' means 'finger' and 'rokuro' means 'wheel' in Japanese), is available through Noriaki's webstore for other pottery enthusiasts to try.

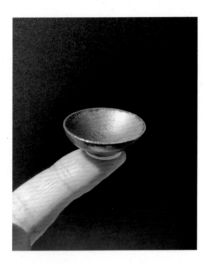

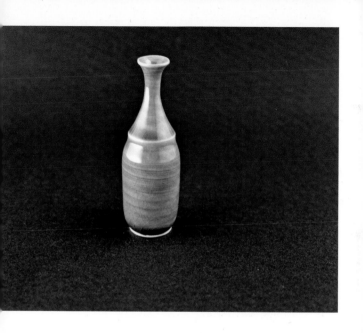

OPPOSITE
Tiny Plate, 2019, Shigaraki clay,
1.2 cm x 3 cm (½ in x 1¼ in)

ABOVE
Tiny Vase, 2023, Shigaraki clay,
7 cm x 2.3 cm (2¾ in x 1 in)

Polly Fern

Polly Fern began painting on ceramics to explore 'illustrating stories upon objects rather than just paper'. Spurred by an interest in decorative antiquities, including jewellery and curiosities, Polly began translating the tradition of heirlooms and the tactility of small objects into clay.

She initially began working on a miniature scale to test oxides and glazes before creating full-sized works. These small pieces offered the perfect opportunity to start an ongoing collaboraton with jewellery designer Becca Hulbert, who turns each ceramic tile into a unique piece of jewellery with baroque accessories and bone clasps. Miniature, hand-formed tiles are now a central part of Polly's repertoire, which has required her to scale down her painting brushes to miniature size too.

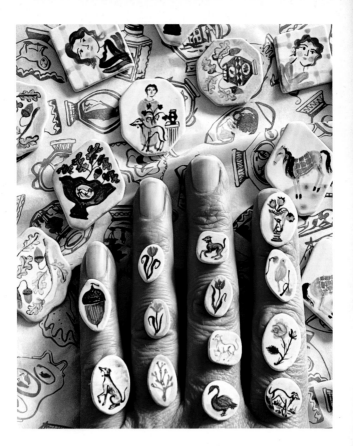

Polly finds many of her inspirations from antique thrifting and shopping, with vintage finds shaping what she makes and paints today. Her imagery frequently includes appearances from her whippets, Edgar and Cedric, as well as portraiture and miniature scenes that continue visual conventions from the 18th and 19th centuries, albeit with a contemporary twist.

PREVIOUS PAGES
(L) *Miniatures for Jewellery*, 2022, Earthenware, Largest piece 3 cm x 2.5 cm (1¼ in x 1 in)
(R) *Miniatures Loaded into the Kiln*, 2023, Earthenware, Largest piece 3 cm x 2.5 cm (1¼ in x 1 in)

LEFT
Miniature Romantic Vase Whippet with Daffodils, 2022, Earthenware, 3 cm x 5 cm (1¼ in x 2 in)

OPPOSITE
Pink Horse Earrings Made with Becca Hulbert, 2023, Earthenware, 3 cm x 2.5 cm (1¼ in x 1 in)

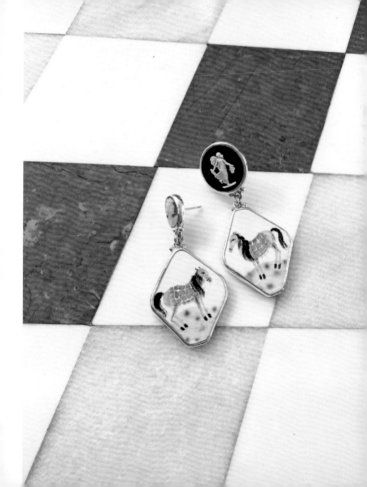

Pottery Cucumber

Pottery Cucumber 陶黄瓜 is a pottery studio run by a husband-and-wife team in Jingdezhen, China.

Jingdezhen is renowned for its porcelain production, which dates to the sixth century. For hundreds of years, the city was the world's largest producer of high-quality wares, earning it its reputation as the 'Porcelain Capital'.

Pottery Cucumber specialises in miniature, classical versions of traditional Chinese pottery, including blue-and-white porcelain. Describing their process, they share that it 'is not very different from…normal-scaled ceramic production', but their work requires 'more care and patience'.

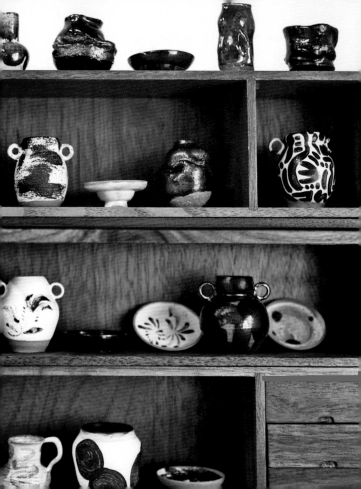

Particularly challenging is the scaling down of complex painted imagery, which requires special tools and fine-tuning. With eye-catching precision and mastery, Pottery Cucumber's work is an homage to historical pottery practices.

Many of their pieces also draw inspiration from nature and appreciation for the everyday. This appreciation is reflected in the typical studio schedule for the artists, who balance their time between ceramics and 'making food and having fun'. Speaking to their work-life balance, Pottery Cucumber shares that they 'create with life as our inspiration'.

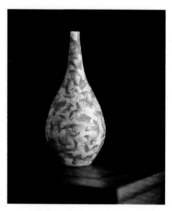

OPPOSITE
Pottery, 2023, Porcelain,
Largest piece 4 cm (1½ in) tall

RIGHT
Vase Decorated with a Hundred Bats, 2023, Porcelain,
4.3 cm x 1.9 cm (1¾ in x ¾ in)

BELOW
Song Dynasty Wine-warmer and Cup, 2023, Porcelain,
Largest piece 3.3 cm (1⅛ in) tall

OPPOSITE
Tea Ceremony, 2023, Earthenware and porcelain,
Largest piece 4 cm (1½ in) tall

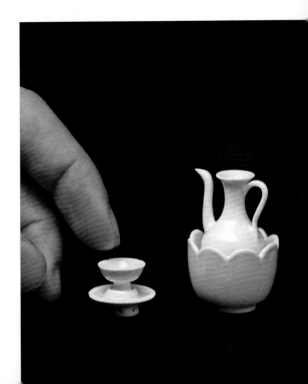

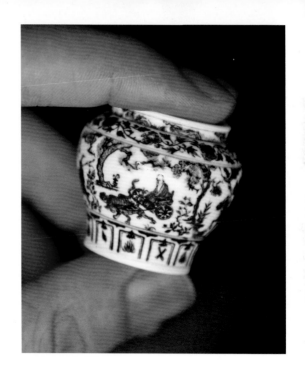

OPPOSITE
Guiguzi Descends the Mountain, 2023,
Porcelain, 2.7 cm x 3.2 cm (1¼ in x 1¼ in)

ABOVE
Blue Plum Ornamental Vase, 2023,
Porcelain, 3.7 cm x 2.2 cm (1½ in x ¾ in)

Ros Lee

Pottery runs in Ros Lee's ロス•リ family. Her parents managed a pottery supplies business and studio, which meant she grew up surrounded by clay.

When she turned 20, Ros started a pottery studio as a subsidiary of her family's business. After moving to Tokyo in 2005 and pursuing further studies in ceramics, Ros launched Polkaros, her own ceramic lifestyle brand, in 2011.

Thirteen years on, Polkaros products are collected and treasured by audiences all around the world. These pieces explore themes that celebrate life and the 'things that bring hope and joy'. Many of Ros' works feature a distinct 'Pierrot' clown face or a sleeping expression; these faces are recurring characters, or ceramic friends, in Ros' practice.

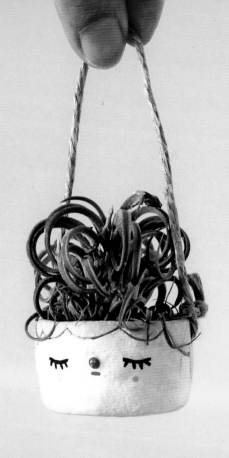

OPPOSITE
 Hanging Pierrot Planter, 2021, Stoneware,
 5 cm x 5 cm (2 in x 2 in)

ABOVE
 Cho, Rumi and Kouma, 2023, Stoneware,
 Largest piece 5 cm x 8 cm (2 in x 3¼ in)

Ros works with a range of materials and techniques that include throwing, pinching, coiling and slab-building. Working in miniature was a natural extension of Ros' ceramic practice, allowing her to translate the recurring themes of her full-sized work into a playful scale. This is further reflected in her porcelain accessories line of tiny brooches and earrings, which bring colour and play into the wearer's daily life.

ABOVE
Carico Cat Figurines, 2022, Stoneware, 2.5 cm x 5.5 cm (1 in x 2¼ in)

OPPOSITE
Mini Pierrot Vase, 2021, Porcelain, 5.5 cm x 5 cm (2¼ in x 2 in)

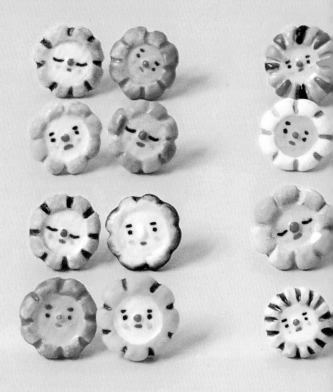

Flower Earrings, 2023, Porcelain, 1.2 cm (½ in)

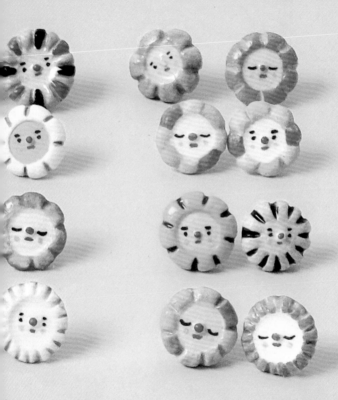

Sam Rin

Sam Rin's 林俪思 pottery reflects her love for Asian art history. Most of her works are directly inspired by existing objects and artefacts, whether seen at museums and galleries or sourced from art textbooks and research.

Sam describes this process of miniaturisation as a 'form of object study, in being forced to properly look at and think about every shape, slope, colour, part of its composition'.

Sam made her first tiny ceramics as a museum intern while crafting mini excavation kits for a children's program. After scrambling to make more than 200 miniature pots with her colleagues, her interest in regional ceramic trade and history compelled her to keep working in a small format. Today, she throws pottery in the evenings after her day job in a museum, using a bright yellow mini wheel.

For Sam, the joy of creating miniature versions of existing ceramics is about cultivating a 'personal relationship with art'. While the original objects may be untouchable in museum displays and cabinets, the process of miniaturisation brings these public cultural artefacts directly into people's lives.

LEFT
πΟπ, 2022, Stoneware,
2.5 cm x 3.1 cm (1 in x 1¼ in)

OPPOSITE
Moon Flask, Pink Pot, Brush Washers and Egrets, 2022-23, Stoneware, Largest piece
4.8 cm x 3.1 cm (2 in x 1¼ in)

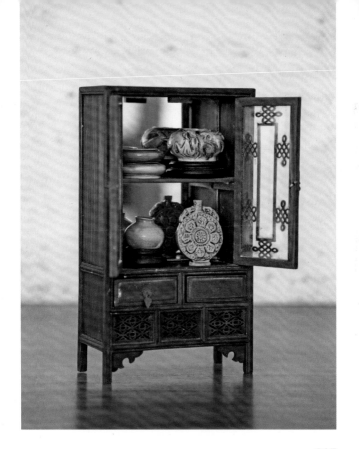

Elephant Pots, 2022-23, Stoneware, Largest piece 3.8 cm x 2.8 cm (1½ in x 1¼ in)

Sung Hyeoun Cho

Sung Hyeoun Cho 조성현, also known as sosoyo, has been working as a ceramicist for more than 25 years.

Based in a small studio in Seoul, South Korea, he is best known for his moon jars: a unique Korean porcelain first made during the Joseon dynasty (1392-1910). Named for their distinctive shape and milky colour, moon jars are traditionally created by combining two hemispherical clay halves; part of their beauty derives from the imperfection created through this manual join.

For Sung Hyeoun, moon jars represent the 'best art that can be done with a spinning wheel'.

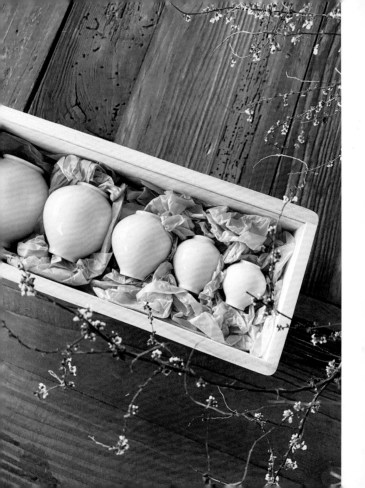

Sung Hyeoun enjoys the slow process of throwing, and relishes the quiet solitude of working alone, immersed in the long process of shaping each unique jar.

While traditional moon jars are large and costly to produce, Sung Hyeoun makes them in a variety of sizes, with more accessible prices. Miniaturising moon jars requires more precision and additional shaping, to maintain the distinct spherical shape. But for the ceramicist, even though 'it is tiring to focus on small things with your eyes, miniature work is fun'.

OPPOSITE
Miniature Moonjar Family, 2022, Korean white clay, Largest piece 7 cm x 7 cm (2¾ in x 2¾ in)

RIGHT
Miniature Moonjar, 2022, Korean white clay, Largest piece 5 cm x 5 cm (2 in x 2 in)

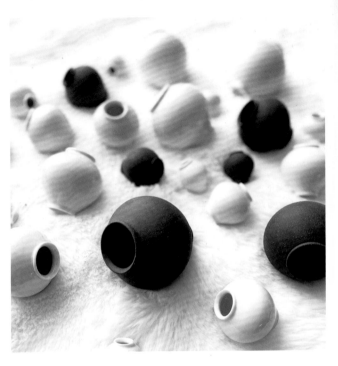

ABOVE
Miniature Moonjar, 2022, Korean white clay and Japanese black clay,
Largest piece 6 cm x 6 cm (2⅓ in x 2⅓ in)

OPPOSITE
Miniature Moonjar Family, 2023, Korean white clay and Japanese black clay,
Largest piece 7 cm x 7 cm (2¾ in x 2¾ in)

234

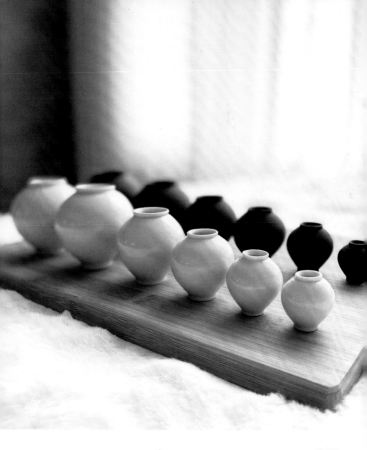

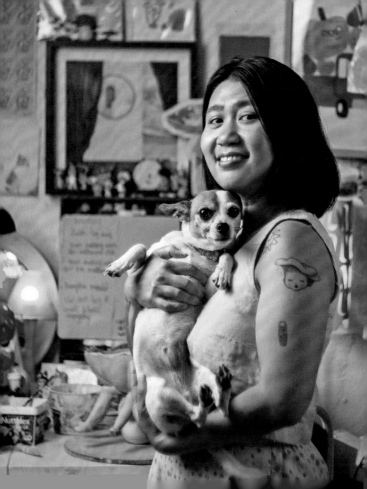

Yang Qiu

It all started with a 'captivating garlic at the farmer's market'.

For the last four years Yang Qiu 丘洋, working under the name Albatross Ceramics, has been casting miniature ceramics from real fruits or vegetables, which are detailed with arm and leg attachments. These small pieces have a surreal and fantastical quality, bordering on the uncanny. For Yang, 'every tiny attachment brings ... immense joy,' and she treats each piece 'like a little baby'.

Yang works with a combined process of mould making and slip-casting to try to accurately capture the distinct surface and texture of the real-life object. Each appendage is carefully hand-built and scaled to match the proportions of the produce in order to maintain a degree of realism.

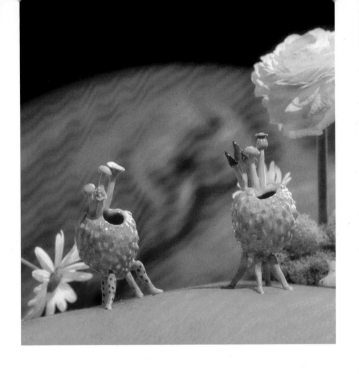

ABOVE
Dancing Lychee 2 (Pink & Green), 2023, Mid-fire clay,
5.4 cm x 4 cm (2¼ in x 1½ in)

OPPOSITE
Dancing Mushroom Island, 2023, Mid-fire clay,
8 cm x 6 cm (3¼ in x 2½ in)

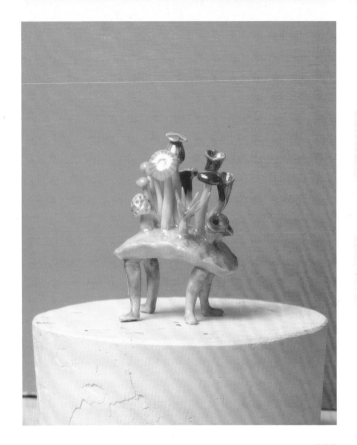

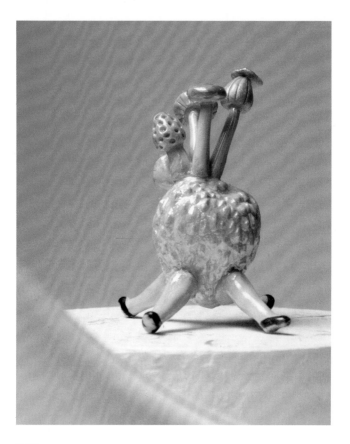

240

Yang describes her works as self-portraits, which 'depict my comfort and confidence in personal spaces'. She says these vegetable likenesses are representative of her experience as an outsider in Australia, who flourishes 'away from the scrutiny of public eyes, rules and standards'. Beyond an obvious love for food, Yang's works reveal an introspective creative rationale.

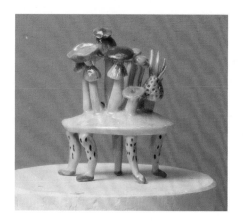

OPPOSITE
Dancing Lychee, 2023, Mid-fire clay,
6.5 cm x 4 cm (2½ in x 1½ in)

ABOVE
Dancing Mushroom Island with Leg Hairs, 2023, Mid-fire clay,
6.8 cm x 6 cm (2¾ in x 2½ in)

ARTIST CONTACTS

ADA VARASCHINI
Ada's Dolls
@adas_dolls

ANDREA FABREGA
tinypots.com

ANNABEL LE
Egg Soda Studio
@annabel.sple
eggsodastudio.com

BX WOO
Wode Ceramics
@wodeceramics

CAROLINA PLATAS
Aww Mini
@aww_mini
awwmini.com

CEREMONY STUDIO
@in.ceremony
inceremony.com

CIELO VIANZON
Clayful Mini Ceramics
@minipotteryproject

CLAIRE PAREROULTJA
@hermannsburgpotters
hermannsburgpotters.com.au

ELEONOR BOSTRÖM
@eleonorbostrom
eleonorbostrom.se

FUNG WING YAN
Fungtaitau
@fungtaitau
fungtaitau.com

GRACE BROWN
Oh Hey Grace
@ohheygrace
ohheygrace.com.au

HAMISH BASSETT
Tiny Pots Melbourne
@tinypotsmelbourne
tinypotsmelbourne.com

HANNAH BILLINGHAM
@hannahbillinghamart
hannahbillinghamart.co.uk

HUI-YONG FORD
@galaxyclay
galaxyclay.com

HYEYOUN SHIN
illy's wall
@illyswall
illyswall.com.au

ACKNOWLEDGEMENTS & THANK YOUS

This book was written on the unceded lands of the Wurundjeri people of the Kulin Nation, where I live and work. I pay respect to their Elders past and present, and all First Nations people.

I would like to extend my thanks to my friends, family, and peers and colleagues who helped make this book possible, and supported it from start to finish. Particular thanks to my chosen family: Malcolm, Rosie and Rocket - you make my life cuter everyday.

ABOUT THE AUTHOR

Sophia Cai 蔡晨昕 is a curator and arts writer based in Naarm/Melbourne, Australia. She is the current Artistic Director of Bus Projects, one of Australia's longest-running artist-run organisations, while maintaining an independent curating and writing practice. When not visiting galleries or museums, Sophia enjoys knitting and taking walks with her greyhound best friends (and half-siblings) Rosie and Rocket.

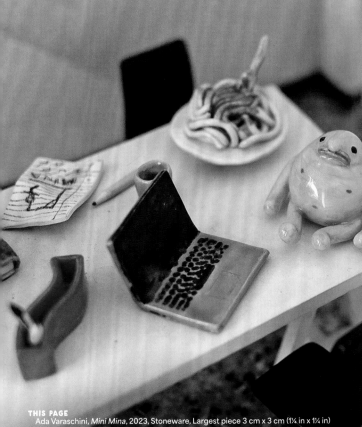

THIS PAGE
Ada Varaschini, *Mini Mina*, 2023, Stoneware, Largest piece 3 cm x 3 cm (1¼ in x 1¼ in)

FOLLOWING PAGE
Jin Seon Kim, *Mwah Friends*, 2023, Porcelain, 3 cm x 0.8 cm (1¼ in x ¾ in)